DANIEL BOUDINET. POLAROID. 1979

ALSO BY ROLAND BARTHES

A Barthes Reader Critical Essays The Eiffel Tower and Other Mythologies Elements of Semiology Empire of Signs The Fashion System The Grain of the Voice Image-Music-Text Incidents The Language of Fashion A Lover's Discourse Michelet Mourning Diary Mythologies The Neutral New Critical Essays On Racine The Pleasure of the Text The Responsibility of Forms Roland Barthes by Roland Barthes The Rustle of Language Sade / Fourier / Loyola The Semiotic Challenge S/Z Writing Degree Zero

CAMERA LUCIDA

CAMERA LUCIDA Reflections on Photography

ROLAND BARTHES

TRANSLATED FROM THE FRENCH BY RICHARD HOWARD

HILL AND WANG A DIVISION OF FARRAR, STRAUS AND GIROUX NEW YORK Hill and Wang A division of Farrar, Straus and Giroux 18 West 18th Street, New York 10011

Copyright © 1980 by Éditions du Seuil Translation copyright © 1981 by Farrar, Straus and Giroux Foreword copyright © 2010 by Geoff Dyer All rights reserved

Printed in the United States of America Originally published in 1980 by Éditions du Seuil, France, as *La Chambre Claire* Published in 1981 in the United States by Hill and Wang This paperback edition, 2010

Library of Congress Control Number: 2010930829 ISBN: 978-0-374-53233-8

www.fsgbooks.com

20 19 18 17 16

Title-page illustration: "Camera lucida," from *The History of Photography* by Beaumont Newhall, Museum of Modern Art, New York.

In homage to L'Imaginaire by Jean-Paul Sartre

CONTENTS

Foreword by Geoff Dyer ix

PART ONE

I. Speciality of the Photograph 3

2. The Photograph Unclassifiable 4

3. Emotion as Departure 8

4. OPERATOR, SPECTRUM and SPECTATOR 9

5. He Who Is Photographed 10

6. The SPECTATOR: Chaos of Tastes 16

7. Photography as Adventure 18

8. A Casual Phenomenology 20

9. Duality 23

10. STUDIUM and PUNCTUM 25

11. Studium 27

12. To Inform 28

13. To Paint 30

14. To Surprise 32

15. To Signify 34

16. To Waken Desire 38

17. The Unary Photograph 40

18. Co-presence of the STUDIUM and the PUNCTUM 42

19. PUNCTUM: Partial Feature 43

20. Involuntary Feature 47

21. Satori 49

22. After-the-Fact and Silence 51

23. Blind Field 55 24. Palinode 60

PART Two 25. "One evening" 63 26. History as Separation 64 27. To Recognize 65 28. The Winter Garden Photograph 67 29. The Little Girl 71 30. Ariadne 73 31. The Family, the Mother 74 32. "THAT-HAS-BEEN" 76 33. The Pose 78 34. The Luminous Rays, Color 80 35. Amazement 82 36. Authentication 85 37. Stasis 89 38. Flat Death 92 39. Time as PUNCTUM 94 40. Private/Public 97 41. To Scrutinize 99 42. Resemblance 100 43. Lineage 103 44. CAMERA LUCIDA 106 45. The "Air" 107 46. The Look III 47. Madness, Pity 115 48. The Photograph Tamed 117

FOREWORD by Geoff Dyer

In 1914 Alfred Stieglitz responded indignantly to a reader who had canceled his subscription to *Camera Work*, the journal in which he had sought to "establish once and for all, the *meaning* of the *idea* photography." Roland Barthes claimed to be delighted by only one of Stieglitz's photographs, but the book in which he made this confession addresses the very issue that had obsessed Stieglitz to the point of mania. For many readers the effect of *Camera Lucida* was exactly the one Stieglitz claimed for *Camera Work*: "photography suddenly assumed a new meaning."

Barthes had long been fascinated by photographs but his exploration of "the phenomenon of photography in its absolute novelty in world history" had its specific origin in a request from Les Cahiers du Cinéma to write something about film. The idea did not appeal. As he told friends, "I've got nothing to say about film, but photography on the other hand . . ." Having agreed to write a short piece for Les Cahiers, Barthes found his reflections on photography (photography "against film") growing into a book written-according to his biographer Louis-Jean Calvet-"at one go, or almost, during the period between 15 April and 3 June 1979." His mother had died in October 1977 and the book became bound up with his grief over her death. Barthes himself said in an interview that the book was "symmetrical to A Lover's Discourse, in the realm of mourning." The whole of the second half of Camera Lucida, in fact, is based around a photograph of his mother-the so-called Winter Garden photograph-taken when she was five: "Something like an essence of the

/ ix

Photograph floated in this particular picture." Just how profoundly Barthes's private grief and the subject of his professional scrutiny had become intermingled is made poignantly clear by the recent publication of *Mourning Diary*.

Barthes liked "to write beginnings" and multiplied this pleasure by writing books of fragments, of repeated beginnings; he also liked prebeginnings: "introductions, sketches," ideas for projected books, books he planned one day to write. So when Nathalie Léger, editor of Mourning Diary, describes it as "the hypothesis of a book desired by him," she is accurate in that it was neither finished nor intended for publication; but she is also describing the typical or ideal condition of the books that were published. In a sense Camera Lucida is the desired book of which Mourning Diary is the mere hypothesis, while itself being a more elaborately formulated series of hypotheses-not a definitive account, but a "Note sur la photographie," as the French edition was modestly (and confidently) subtitled. Barthes's preferred way of presenting his hypotheses was in the form of linked aphorisms, and, as Susan Sontag noted, "it is the nature of aphoristic thinking to be always in a state of concluding." The paradox, then, is that this man who liked first words (and adored paradoxes) offered his provisional findings as if they were the last word. Needless to say, this last word was always susceptible to further elaboration and refinement, to further beginnings. This is how Barthes's prose acquires its signature style of compression and flow, a summing-up that is also a perpetual setting-forth. The result, an ever-increasing subtleness or delicacy of assertion, approximates the defining quality of his mother, as captured, uniquely, in the Winter Garden photograph: "the assertion of a gentleness." If there is a consoling appropriateness about this, then, by the same token, there was a cruel inevitability about Barthes's work being curtailed by his early death (less than two months after the French publication of Camera Lucida). He was one of those writers whose life's work was destined, by increments, to remain unfinished.

In a way, the death of the mother was fortuitous in that it confirmed something Barthes had suspected: that his fascination with the medium-as he glibly admitted in a radio interview in early 1977- "probably has to do with death. Perhaps it's an interest that is tinged with necrophilia, to be honest, a fascination with what has died but is represented as wanting to be alive." By the end of the year his tone had changed. "If photography is to be discussed on a serious level, it must be described in relation to death," he told another interviewer. "It's true that a photograph is a witness, but a witness of something that is no more." This is classic Barthes: an insight into the nature of an event or thing-"text" was his consis-tently preferred term-is also a comment of his own personal experience. While Barthes emphasized photography's indexical relation to the world, its "evidential force," he also believed that, ultimately, "the photographer bears witness essentially to his own subjectivity." In keeping with this, the book *about* photography is a mediated portrait of the workings of his own mind. Michel Foucault made a similar if more generalized point in the eulogy delivered at the Collège de France in April 1980, praising Barthes's "paradoxical power of understanding things as they are and of inventing them with amazing freshness." Barthes's method, in other words, worked exactly like the element of the photograph that he famously termed the "punctum": "what I add to the photograph and what is nonetheless already there."

The extent to which this way of proceeding could involve remaking photography in Barthes's own image is nicely brought out by his discussion of Robert Mapplethorpe's photograph of a young man, at the far left of the frame, with his left arm extended across to the opposite border. Entranced by the "blissful eroticism" of the image, Barthes likes the way "the photographer has caught the boy's hand (the boy is Mapplethorpe himself, I believe) at just the right degree of openness." The last of the prefatory photographs in *Roland Barthes by Roland Barthes* is a full-page portrait of the author lighting a cigarette, captioned—with gorgeous brevity and vanity— "Left-handed." So there is a beautiful vanity and irony in the fact that the Mapplethorpe is actually printed back-to-front.* It should

*I am grateful to David Campany for pointing this out.

be the *right* arm that is extended across to the left-hand side of the frame, but through this felicitous accident, the projected ideal of desire has turned into a representation of Barthes himself.

The increasingly autobiographical tilt and lilt of Barthes's writing was regarded, in some quarters, as symptomatic of a diminution of the rigor that had marked his first incarnation as systematizer and semiologist. By the mid-1980s, the work of Barthes, Lacan, Foucault, Derrida, et al. had been absorbed wholesale into the Englishspeaking academy. "Theory" became an indispensable part of the cultural studies mainstream. The excitement and energy generated by these challenging new ways of reading texts was matched by a corresponding indignation and resistance, particularly in Britain, but the ease with which the European challenge to traditional academic orthodoxy installed itself as a new orthodoxy was shocking to behold. Cowper's famous jibe about Pope-that he "Made poetry a mere mechanick art; / And ev'ry warbler has his tune by heart"-was rendered suddenly contemporary by the clutch of sub-Barthesian, Foucault-drenched academics discoursing and signifiedand-signifying away for all they were worth. Subsumed in a general mass of cultural theory, the works in which Barthes most clearly revealed himself as a *writer* were the least valued. An article in the New Statesman assessing Barthes's importance ten years after his death dwelled almost exclusively on his semiotics, on works such as Image-Music-Text and Mythologies, while dismissing the later, more personal works as "marginal, lacking the satisfying stamp of authority."

All of which was in sharp contrast to Sontag's approving observation of the way that "his voice became more and more personal," that he derived pleasure from "the dismantling of his own authority," and that the marginal would come to seem absolutely central to Barthes's achievement. In time, Sontag rightly predicted, the theorist who had famously proclaimed the death of the author would come to appear "as a rather traditional *promeneur solitaire*" (one of whose preoccupations, incidentally, would be his abiding loneliness).* Writing in the immediate aftermath of Barthes's death, Italo *See, particularly, "Soirées de Paris" in *Incidents* (Berkeley: University of California Press, 1992). Calvino offered a similarly nuanced view of two Bartheses: "the one who subordinated everything to the rigor of a method, and the one whose only sure criterion was pleasure (the pleasure of the intelligence and the intelligence of pleasure). The truth is that these two Barthes are really one."

Between them, Sontag and Calvino accurately mapped the territory in which Barthes's posthumous reputation would come to reside. The earlier, much-anthologized essays in which Barthes first wrote about photography—"Rhetoric of the Image" and "The Photographic Message"—today seem intensely reader-resistant. But while Barthes, in *Camera Lucida*, explicitly distanced himself from "sociologists and semiologists," the residue of the earlier systematizing efforts can still be discerned, like the ghostly imprint of scaffolding, a grid on which he is no longer reliant. And even when Barthes is at his least theoretical, one still senses what Perry Anderson calls "the formative role of rhetoric" in his style—a formation shared by many of his illustrious Parisian contemporaries. The potential costs of this, Anderson goes on, are obvious: "arguments freed from logic, propositions from evidence."

Nevertheless, a programmatic approach can be extracted from the book. In this respect Camera Lucida has become a victim of its own success. The punctum is an apparently irrelevant detail, extraneous to a picture's intended purpose or composition and yet, once noticed, essential to it. This idea proved so seductive that a punctum—which, crucially, was not there in all photographs, which snagged Barthes's attention almost accidentally—became almost a necessity. As the search for a picture's punctum took on the quality of a critical dragnet—we know it's in there somewhere!—so this surprising detail lost its capacity to surprise, offered the same kind of unconcealed or overt satisfaction as the studium to which it had originally been opposed: something that any photograph provided and that we expected to find, as of right.*

/ xiii

^{*}For more on how the opposition between *punctum* and *studium* is "blurred" within *Camera Lucida* itself, see Jacques Rancière, *The Emancipated Spectator* (New York: Verso, 2009), pp. 110–16.

A related problem is that Barthes's thought is inseparable from the elegance and cunning with which it is formulated. Style, as Martin Amis rightly insists, "is not something grappled on to regular prose; it is intrinsic to perception." In The Pleasure of the Texta useful guide, naturally, to his own work-Barthes had asked, "What if knowledge itself were *delicious*?" The corollary is: What if that knowledge were robbed of all that made it so tasty? The tone of "sustained astonishment" with which Barthes discovers that photography represents the advent of the self as other; or articulates the strange tense of Alexander Gardner's portrait of Lewis Payne: "He is dead and he is going to die"; or notices "that rather terrible thing which is there in every photograph: the return of the dead" . . . None of this lends itself to bald summary. To copy out and formalize Barthes's argument is not simply to diminish it, but to rob it of so many subtleties as to misrepresent it entirely (all in the name of representing it more clearly and rigorously).*

Full of what Anderson calls "eclectic coquetries" and flourishes of "flamboyant eloquence," Barthes's prose is all the time delighting in its own refinement. This is not to everyone's taste. As he asked (again in *The Pleasure of the Text*): "Why, in a text, all this verbal display?" He goes on to say that the "prattle of the text is merely that foam of language." For his detractors this is not the foam of a tide or stream but of an overscented bubble bath to which one can develop an allergic reaction; for his admirers it is something in which to luxuriate. This is crucial to Barthes's appeal: a prose built around complex ideas that somehow manages to *pamper* the reader. Part of the fun of reading him is in seeing rhetoric brought to a point of exquisite jotting—and vice versa.

By the time of *Camera Lucida*, Barthes's ornate sentences, with all their colons and semicolons, italics, hyphens, ellipses, and parentheses, came quite naturally to him. Where one might remember particular scenes or sentences in a novel, with Barthes the focus narrows to favorite deployments or permutations of punctuation.

^{*}See, for example, Michael Fried, *Why Photography Matters as Art as Never Before* (New Haven: Yale University Press, 2008), pp. 95–114.

To take just one example: The most famous parenthesis in postwar literature is probably the one in *Lolita* where Humbert Humbert provides details of the death of his mother: "(picnic, lightning)." It's proof, in spectacular miniature, of Nabokov's exuberant facility. But the moment when Barthes, remembering *his* dead mother's ivory powder box, adds, almost inaudibly, "(I loved the sound of its lid)" is intensely moving and just as expressive of the supple intimacy of his own style. It also reminds us that, for all his extravagancies, there is often something understated about Barthes. Everything about the prose is so personalized that even the printed page seems handwritten with a favorite pen. And not only that: thanks to the delicacy and skill of his translator, Richard Howard, English-speaking readers can enjoy the delusion that they suddenly have the ability to read French.

In Roland Barthes, Barthes had warned readers that "it must all be considered as if spoken by a character in a novel," and in his last years he talked about the possibility of writing a novel. Whether he would ever have realized this ambition is impossible to say, but it bears emphasizing that a knowledge of or even interest in photography is no more a precondition for reading Camera Lucida than an interest in young girls is necessary for embarking on Lolita. Camera Lucida is a glimpse of the world as rendered by a master stylist; as such it offers a version of the pleasures derived from the best discursive fiction. "For me the noise of Time is not sad: I love bells, clocks, watches-and I recall that at first photographic implements were related to techniques of cabinetmaking and the machinery of precision: cameras, in short, were clocks for seeing, and perhaps in me someone very old still hears in the photographic mechanism the living sound of the wood." In such passages Barthes seems like the true heir-in modishly abbreviated style-of Proust.

Barthes entertained few doubts as to his literary gifts and, in interviews, was suavely sure of the "entirely subjective" method whereby a few "arbitrarily chosen photographs" would suffice to examine the "new type of image" that came into existence "all at once, around 1822." "Whether this will please photographers," he

1 xv

conceded, "remains to be seen." In Britain, particularly for those pursuing a double life as photographers and academics teaching on cultural or media studies courses-Victor Burgin was the representative figure—Barthes's work provided a framework that was creative as well as theoretical. For the most part, though, the best American photographers-those adhering to what John Szarkowski deemed "photography's central sense of purpose and aesthetic: the precise and lucid description of significant fact"-were not so much hostile as indifferent to Barthes's efforts. The business of making images was dominated, as it always had been, by photographers looking at one another's pictures and swapping advice and experience about technical matters: lenses, films, types of printing paper. Looking back on the period in the 1970s when some of the photos in his book Passing Through Eden were made, Tod Papageorge remembered, "Unlike most of the photographers I knew, I bothered to acquaint myself with the major books" by Barthes, Sontag, and others. Not that any of this "intellectual commotion" found its way into the pictures. For the record, Papageorge is adamant that "Garry Winogrand never read Roland Barthes, and found whatever he'd seen of [Janet] Malcolm's and Sontag's original articles about photography in the New Yorker and the New York Review of Books grimly laughable." Papageorge, then, was an unusually sympathetic reader-practitioner but he "was more interested in what other photographers had to say about the state of our common medium." And while Barthes's whole purpose was to define the "newness" of photographic images (that is, what made them different from paintings), some of the people most deeply involved in the medium were not convinced. As Mark Haworth-Booth, the former curator of photography at the Victoria and Albert Museum in London, mischievously remarked, "I recently hung up a painting in our new dining room and realized for the first time that my mother must have picked the sweet peas in it."*

*At the risk of nationalist carping, it is worth mentioning, too, that Barthes's account of the origins of photography is willfully Francocentric, a competitive collaboration between Niépce and Daguerre; the Englishman William Henry Fox Talbot does not merit even a mention.

Another irony is that this "newness"—almost 150 years old by the time Barthes wrote his book!—now seems almost obsolete. For Barthes the photograph was not just a record of something that is absent but of "reality in a past state," a record "of *what has been*." Much of what Barthes says about photography rings true only if we are thinking of its traditional chemical/mechanical phase. Polaroids provided instant *memories* but digital photography seems entirely devoid of any qualities of past time. Far from invalidating Barthes's arguments, however, the self-fueling, self-consuming present of the digital tense means that *Camera Lucida* has acquired the internal glow of its own preoccupation with photography as a technology in the process of becoming past, part of what has been.

It is ironic, then, that one of the most memorable tributes to Barthes comes in the form of an image that would have been inconceivable without the benefits of digital technology. In 2004 Idris Khan made a photograph entitled "Every Page . . . from Roland Barthes's *Camera Lucida*," in which he combined the pages in a single image so that Barthes's text and the pictures reproduced in the book peer at the viewer through a dense fog of their own making. (The return of the read!) It is as if decaying and enduring memories of the book's successive pleasures—first words and last—have been compacted into a ghostly blur of almost impenetrable purity.

NOTES

- ix "establish once and for all": Alfred Stieglitz, *Photographs and Writings*, ed. Sarah Greenough (Washington: National Gallery of Art/Bulfinch Press, 1999), p. 197.
- ix "photography suddenly assumed a new meaning": Ibid.
- ix "the phenomenon of photography": Roland Barthes, *The Grain of the Voice* (New York: Hill and Wang, 1985), p. 357.
- ix "I've got nothing to say about film": Louis-Jean Calvet, *Roland Barthes: A Biography* (Bloomington: Indiana University Press, 1995), p. 236.
- ix "against film": Barthes, The Grain of the Voice, p. 359.
- ix "at one go, or almost": Calvet, Barthes, p. 235.
- ix "symmetrical to A Lover's Discourse": Barthes, The Grain of the Voice, p. 352.

- x "to write beginnings": Roland Barthes, *Roland Barthes by Roland Barthes* (New York: Hill and Wang, 2010), p. 94.
- x "introductions, sketches": Ibid.
- x "the hypothesis of a book desired by him": Nathalie Léger in Roland Barthes, *Mourning Diary* (New York: Hill and Wang, 2010), p. x.
- x "it is the nature of aphoristic thinking": Susan Sontag, ed., *A Barthes Reader* (New York: Hill and Wang, 1982), p. xii.
- xi "probably has to do with death": Calvet, Barthes, p. 220.
- xi "If photography is to be discussed": Barthes, The Grain of the Voice, p. 356.
- xi "the photographer bears witness": Ibid.
- xi "paradoxical power of understanding things": Didier Eribon, *Foucault* (London: Faber, 1992), p. 82.
- xii "Made poetry a mere mechanick art": William Cowper, Esq., *Poems* (Boston: Crosby and Nichols, 1863), p. 28.
- xii "his voice became more and more personal": Sontag, A Barthes Reader, p. xvii.
- xii "the dismantling of his own authority": Ibid., p. xxx.
- xii "as a rather traditional promeneur solitaire": Ibid., p. viii.
- xiii "the one who subordinated everything": Italo Calvino, *The Literature Machine* (London: Secker & Warburg, 1987), p. 302.
- xiii "the formative role of rhetoric": Perry Anderson, *The New Old World* (New York: Verso, 2009), p. 143.
- xiii "arguments freed from logic": Ibid.
- xiv "is not something grappled on": Martin Amis, *The War Against Cliché* (New York: Talk Miramax Books/Hyperion, 2001), p. 467.
- xiv "What if knowledge itself were *delicious*?": Roland Barthes, *The Pleasure of the Text* (New York: Hill and Wang, 1975), p. 23.
- xiv "sustained astonishment": Barthes, The Grain of the Voice, p. 357.
- xiv "eclectic coquetries": Anderson, The New Old World, p. 143.
- xiv "flamboyant eloquence": Ibid.
- xiv "Why, in a text": Barthes, The Pleasure of the Text, p. 23.
- xiv "prattle of the text": Ibid., p. 4.
- xv "(picnic, lightning)": Vladimir Nabokov, *Lolita* (New York: Vintage, 1989), p. 10.
- xv "it must all be considered": Barthes, Roland Barthes, p. v.
- xv "entirely subjective": Barthes, The Grain of the Voice, p. 357.
- xv "arbitrarily chosen photographs": Ibid.
- xv "new type of image": Ibid.
- xv "all at once, around 1822": Ibid.
- xv "Whether this will please photographers": Ibid., p. 351.
- xvi "photography's central sense of purpose and aesthetic": John Szarkowski, quoted in Walker Evans: The Hungry Eye (London: Thames and Hudson, 1993), p. 10.

xviii /

- xvi "Unlike most of the photographers I knew": Tod Papageorge, *Passing Through Eden* (Gottingen: Steidl, 2007), p. iv.
- xvi "intellectual commotion": Ibid.
- xvi "Garry Winogrand never read Roland Barthes": Ibid.
- xvi "was more interested": Ibid.
- xvi "newness": Barthes, The Grain of the Voice, p. 357.
- xvi "I recently hung up a painting": Haworth-Booth in an e-mail to Geoff Dyer.

Part One

One day, quite some time ago, I happened on a photograph of Napoleon's youngest brother, Ierome, taken in 1852. And I realized then, with an amazement I have not been able to lessen since: "I am looking at eyes that looked at the Emperor." Sometimes I would mention this amazement, but since no one seemed to share it, nor even to understand it (life consists of these little touches of solitude), I forgot about it. My interest in Photography took a more cultural turn. I decided I liked Photography in opposition to the Cinema, from which I nonetheless failed to separate it. This question grew insistent. I was overcome by an "ontological" desire: I wanted to learn at all costs what Photography was "in itself," by what essential feature it was to be distinguished from the community of images. Such a desire really meant that beyond the evidence provided by technology and usage, and despite its tremendous contemporary expansion, I wasn't sure that Photography existed, that it had a "genius" of its own.

13

Who could help me?

From the first step, that of classification (we must surely classify, verify by samples, if we want to constitute a corpus), Photography evades us. The various distributions we impose upon it are in fact either empirical (Professionals / Amateurs), or rhetorical (Landscapes / Objects / Portraits / Nudes), or else aesthetic (Realism / Pictorialism), in any case external to the object, without relation to its essence, which can only be (if it exists at all) the New of which it has been the advent; for these classifications might very well be applied to other, older forms of representation. We might say that Photography is unclassifiable. Then I wondered what the source of this disorder might be.

The first thing I found was this. What the Photograph reproduces to infinity has occurred only once: the Photograph mechanically repeats what could never be repeated existentially. In the Photograph, the event is never transcended for the sake of something else: the Photograph always leads the corpus I need back to the body I see; it is the absolute Particular, the sovereign Contingency, matte and somehow stupid, the *This* (this photograph, and not Photography), in short, what Lacan calls the *Tuché*, the Occasion, the Encounter, the Real, in its indefatigable expression. In order to designate reality, Buddhism says sunya, the void; but better still: tathata, as Alan Watts has it, the fact of being this, of being thus, of being so; tat means that in Sanskrit and suggests the gesture of the child pointing his finger at something and saying: that, there it is, lo! but says nothing else; a photograph cannot be transformed (spoken) philosophically, it is wholly ballasted by the contingency of which it is the weightless, transparent envelope. Show your photographs to someone—he will immediately show you his: "Look, this is my brother; this is me as a child," etc.; the Photograph is never anything but an antiphon of "Look," "See," "Here it is"; it points a finger at certain vis-à-vis, and cannot escape this pure deictic language. This is why, insofar as it is licit to speak of a photograph, it seemed to me just as improbable to speak of the Photograph.

A specific photograph, in effect, is never distinguished from its referent (from what it represents), or at least it is not *immediately* or *generally* distinguished from its referent (as is the case for every other image, encumbered from the start, and because of its status—by the way in which the object is simulated): it is not impossible to perceive the photographic signifier (certain professionals do so), but it requires a secondary action of knowledge or of reflection. By nature, the Photograph (for convenience's sake, let us accept this universal, which for the moment refers only to the tireless repetition of contingency) has something tautological about it: a pipe, here, is always and intractably a pipe. It is as if the Photograph always carries its referent with itself, both affected by the same amorous or funereal immobility, at the very heart of the moving world: they are glued together, limb by limb, like the condemned man and the corpse in certain tortures; or even like those pairs of fish (sharks, I think, according to Michelet) which navigate in convoy, as though united by an eternal coitus. The Photograph belongs to that class of laminated objects whose two leaves cannot be separated without destroying them both: the windowpane and the landscape, and why not: Good and Evil, desire and its object: dualities we can conceive but not perceive (I didn't yet know that this stubbornness of the Referent in always being there would produce the essence I was looking for).

This fatality (no photograph without something or someone) involves Photography in the vast disorder of objects—of all the objects in the world: why choose (why photograph) this object, this moment, rather than some other? Photography is unclassifiable because there is no reason to mark this or that of its occurrences; it aspires, perhaps, to become as crude, as certain, as noble as a sign, which would afford it access to the dignity of a language: but for there to be a sign there must be a mark; deprived of a principle of marking, photographs are signs which don't take, which turn, as milk does. Whatever it grants to vision and whatever its manner, a photograph is always invisible: it is not it that we see.

In short, the referent adheres. And this singular adherence makes it very difficult to focus on Photography. The books which deal with it, much less numerous moreover than for any other art, are victims of this difficulty. Some

are technical; in order to "see" the photographic signifier, they are obliged to focus at very close range. Others are historical or sociological; in order to observe the total phenomenon of the Photograph, these are obliged to focus at a great distance. I realized with irritation that none discussed precisely the photographs which interest me, which give me pleasure or emotion. What did I care about the rules of composition of the photographic landscape, or, at the other end, about the Photograph as familv rite? Each time I would read something about Photography, I would think of some photograph I loved, and this made me furious. Myself, I saw only the referent, the desired object, the beloved body; but an importunate voice (the voice of knowledge, of scientia) then adjured me, in a severe tone: "Get back to Photography. What you are seeing here and what makes you suffer belongs to the category 'Amateur Photographs,' dealt with by a team of sociologists; nothing but the trace of a social protocol of integration, intended to reassert the Family, etc." Yet I persisted; another, louder voice urged me to dismiss such sociological commentary; looking at certain photographs, I wanted to be a primitive, without culture. So I went on, not daring to reduce the world's countless photographs, any more than to extend several of mine to Photography: in short, I found myself at an impasse and, so to speak, "scientifically" alone and disarmed.

Then I decided that this disorder and this dilemma, revealed by my desire to write on Photography, corresponded to a discomfort I had always suffered from: the uneasiness of being a subject torn between two languages, one expressive, the other critical; and at the heart of this critical language, between several discourses, those of sociology, of semiology, and of psychoanalysisbut that, by ultimate dissatisfaction with all of them, I was bearing witness to the only sure thing that was in me (however naïve it might be): a desperate resistance to any reductive system. For each time, having resorted to any such language to whatever degree, each time I felt it hardening and thereby tending to reduction and reprimand, I would gently leave it and seek elsewhere: I began to speak differently. It was better, once and for all, to make my protestation of singularity into a virtue-to try making what Nietzsche called the "ego's ancient sovereignty" into an heuristic principle. So I resolved to start my inquiry with no more than a few photographs, the ones I was sure existed for me. Nothing to do with a corpus: only some bodies. In this (after all) conventional debate between science and subjectivity. I had arrived at this curious notion: why mightn't there be, somehow, a new science for each object? A mathesis singularis (and no longer universalis)? So I decided to take myself as mediator for all Photography. Starting from a few personal impulses, I would try to formulate the fundamental feature, the universal without which there would be no Photography.

So I make myself the measure of photographic "knowledge." What does my body know of Photography? I observed that a photograph can be the object of three practices (or of three emotions, or of three intentions): to do, to undergo, to look. The *Operator* is the Photographer. The *Spectator* is ourselves, all of us who glance through collections of photographs—in magazines and newspapers, in books, albums, archives . . . And the person or thing photographed is the target, the referent, a kind of little simulacrum, any *eidolon* emitted by the object, which I should like to call the *Spectrum* of the Photograph, because this word retains, through its root, a relation to "spectacle" and adds to it that rather terrible thing which is there in every photograph: the return of the dead.

One of these practices was barred to me and I was not to investigate it: I am not a photographer, not even an amateur photographer: too impatient for that: I must see right away what I have produced (Polaroid? Fun, but disappointing, except when a great photographer is involved). I might suppose that the *Operator's* emotion (and consequently the essence of Photography-accordingto-the-Photographer) had some relation to the "little

19

hole" (stenope) through which he looks, limits, frames, and perspectivizes when he wants to "take" (to surprise). Technically, Photography is at the intersection of two quite distinct procedures; one of a chemical order: the action of light on certain substances; the other of a physical order: the formation of the image through an optical device. It seemed to me that the Spectator's Photograph descended essentially, so to speak, from the chemical revelation of the object (from which I receive, by deferred action, the rays), and that the Operator's Photograph, on the contrary, was linked to the vision framed by the keyhole of the camera obscura. But of that emotion (or of that essence) I could not speak, never having experienced it; I could not join the troupe of those (the majority) who deal with Photography-according-to-the-Photographer. I possessed only two experiences: that of the observed subject and that of the subject observing ...

It can happen that I am observed without knowing it, and again I cannot speak of this experience, since I have determined to be guided by the consciousness of my feelings. But very often (too often, to my taste) I have been photographed and knew it. Now, once I feel myself observed by the lens, everything changes: I constitute myself in the process of "posing," I instantaneously make another body for myself, I transform myself in advance into an image. This transformation is an active one: I feel that the Photograph creates my body or mortifies it, according to its caprice (apology of this mortiferous power: certain Communards paid with their lives for their willingness or even their eagerness to pose on the barricades: defeated, they were recognized by Thiers's police and shot, almost every one).

Posing in front of the lens (I mean: knowing I am posing, even fleetingly), I do not risk so much as that (at least, not for the moment). No doubt it is metaphorically that I derive my existence from the photographer. But though this dependence is an imaginary one (and from the purest image-repertoire), I experience it with the anguish of an uncertain filiation: an image-my imagewill be generated: will I be born from an antipathetic individual or from a "good sort"? If only I could "come out" on paper as on a classical canvas, endowed with a noble expression-thoughtful, intelligent, etc.! In short, if I could be "painted" (by Titian) or drawn (by Clouet)! But since what I want to have captured is a delicate moral texture and not a mimicry, and since Photography is anything but subtle except in the hands of the very greatest portraitists, I don't know how to work upon my skin from within. I decide to "let drift" over my lips and in my eyes a faint smile which I mean to be "indefinable," in which I might suggest, along with the qualities of my nature, my amused consciousness of the whole photographic ritual: I lend myself to the social game, I pose, I know I am posing, I want you to know that I am posing, but (to square the circle) this additional message must in no way alter the precious essence of my individuality: what I am,

/ I I

apart from any effigy. What I want, in short, is that my (mobile) image, buffeted among a thousand shifting photographs, altering with situation and age, should always coincide with my (profound) "self"; but it is the contrary that must be said: "myself" never coincides with my image; for it is the image which is heavy, motionless, stubborn (which is why society sustains it), and "myself" which is light, divided, dispersed; like a bottle-imp, "myself" doesn't hold still, giggling in my jar: if only Photography could give me a neutral, anatomic body, a body which signifies nothing! Alas, I am doomed by (wellmeaning) Photography always to have an expression: my body never finds its zero degree, no one can give it to me (perhaps only my mother? For it is not indifference which erases the weight of the image-the Photomat always turns you into a criminal type, wanted by the police-but love, extreme love).

To see oneself (differently from in a mirror): on the scale of History, this action is recent, the painted, drawn, or miniaturized portrait having been, until the spread of Photography, a limited possession, intended moreover to advertise a social and financial status—and in any case, a painted portrait, however close the resemblance (this is what I am trying to prove) is not a photograph. Odd that no one has thought of the *disturbance* (to civilization) which this new action causes. I want a History of Looking. For the Photograph is the advent of myself as other: a cunning dissociation of consciousness from identity. Even odder: it was *before* Photography that men had the most to say about the vision of the double. Heautoscopy was compared with an hallucinosis; for centuries this was a great mythic theme. But today it is as if we repressed the profound madness of Photography: it reminds us of its mythic heritage only by that faint uneasiness which seizes me when I look at "myself" on a piece of paper.

This disturbance is ultimately one of ownership. Law has expressed it in its way: to whom does the photograph belong? Is landscape itself only a kind of loan made by the owner of the terrain? Countless cases, apparently, have expressed this uncertainty in a society for which being was based on having. Photography transformed subject into object, and even, one might say, into a museum object: in order to take the first portraits (around 1840) the subject had to assume long poses under a glass roof in bright sunlight; to become an object made one suffer as much as a surgical operation; then a device was invented, a kind of prosthesis invisible to the lens, which supported and maintained the body in its passage to immobility: this headrest was the pedestal of the statue I would become, the corset of my imaginary essence.

The portrait-photograph is a closed field of forces. Four image-repertoires intersect here, oppose and distort each other. In front of the lens, I am at the same time: the one I think I am, the one I want others to think I am, the one the photographer thinks I am, and the one he makes use of to exhibit his art. In other words, a strange action: I do not stop imitating myself, and because of this, each time I am (or let myself be) photographed, I invariably suffer from a sensation of inauthenticity, sometimes of imposture (comparable to certain nightmares). In terms of image-repertoire, the Photograph (the one I intend) represents that very subtle moment when, to tell the truth, I am neither subject nor object but a subject who feels he is becoming an object: I then experience a micro-version of death (of parenthesis): I am truly becoming a specter. The Photographer knows this very well, and himself fears (if only for commercial reasons) this death in which his gesture will embalm me. Nothing would be funnier (if one were not its passive victim, its plastron, as Sade would say) than the photographers' contortions to produce effects that are "lifelike": wretched notions: they make me pose in front of my paintbrushes, they take me outdoors (more "alive" than indoors), put me in front of a staircase because a group of children is playing behind me, they notice a bench and immediately (what a windfall!) make me sit down on it. As if the (terrified) Photographer must exert himself to the utmost to keep the Photograph from becoming Death. But I-already an object, I do not struggle. I foresee that I shall have to wake from this bad dream even more uncomfortably; for what society makes of my photograph, what it reads there, I do not know (in any case, there are so many readings of the same face); but when I discover myself in the product of this operation, what I see is that I have become Total-Image, which is to say, Death in person; others-the Other-do not dispossess me of myself, they turn me, ferociously, into an object, they put me at their mercy, at their disposal, classified in a file, ready for the subtlest deceptions: one day an excellent photographer took my picture; I believed I could read in his image the distress of a recent bereavement: for once Photography had restored me to myself, but soon afterward I was to find this same photograph on the cover of a pamphlet; by the artifice of printing, I no longer had anything but a horrible disinternalized countenance, as sinister and repellent as the image the authors wanted to give of my language. (The "private life" is nothing but that zone of space, of time, where I am not an image, an object. It is my *political* right to be a subject which I must protect.)

Ultimately, what I am seeking in the photograph taken of me (the "intention" according to which I look at it) is Death: Death is the eidos of that Photograph. Hence, strangely, the only thing that I tolerate, that I like, that is familiar to me, when I am photographed, is the sound of the camera. For me, the Photographer's organ is not his eye (which terrifies me) but his finger: what is linked to the trigger of the lens, to the metallic shifting of the plates (when the camera still has such things). I love these mechanical sounds in an almost voluptuous way, as if, in the Photograph, they were the very thing-and the only thing -to which my desire clings, their abrupt click breaking through the mortiferous layer of the Pose. For me the noise of Time is not sad: I love bells, clocks, watchesand I recall that at first photographic implements were related to techniques of cabinetmaking and the machinery of precision: cameras, in short, were clocks for seeing, and perhaps in me someone very old still hears in the photographic mechanism the living sound of the wood.

15

The disorder which from the very first I had observed in Photography—all practices and all subjects mixed up together—I was to rediscover in the photographs of the *Spectator* whom I was and whom I now wanted to investigate.

I see photographs everywhere, like everyone else, nowadays; they come from the world to me, without my asking; they are only "images," their mode of appearance is heterogeneous. Yet, among those which had been selected, evaluated, approved, collected in albums or magazines and which had thereby passed through the filter of culture, I realized that some provoked tiny jubilations, as if they referred to a stilled center, an erotic or lacerating value buried in myself (however harmless the subject may have appeared); and that others, on the contrary, were so indifferent to me that by dint of seeing them multiply, like some weed. I felt a kind of aversion toward them, even of irritation: there are moments when I detest Photographs: what have I to do with Atget's old tree trunks, with Pierre Boucher's nudes, with Germaine Krull's double exposures (to cite only the old names)? Further: I realized that I have never liked all the pictures by any one photographer: the only thing by Stieglitz that delights me (but to ecstasy) is his most famous image ("The Horse-Car Terminal," New York, 1893); a certain picture by Mapplethorpe led me to think I had found "my" photogra-

"Only Stieglitz's most famous photograph delights me . . ."

A. Stieglitz: The Horse-Car Terminal. New York, 1893

pher; but I hadn't—I don't like all of Mapplethorpe. Hence I could not accede to that notion which is so convenient when we want to talk history, culture, aesthetics—that notion known as an artist's style. I felt, by the strength of my "investments," their disorder, their caprice, their enigma, that Photography is an *uncertain* art, as would be (were one to attempt to establish such a thing) a science of desirable or detestable bodies.

I saw clearly that I was concerned here with the impulses of an overready subjectivity, inadequate as soon as articulated: I like / I don't like: we all have our secret chart of tastes, distastes, indifferences, don't we? But just so: I have always wanted to remonstrate with my moods; not to justify them; still less to fill the scene of the text with my individuality; but on the contrary, to offer, to extend this individuality to a science of the subject, a science whose name is of little importance to me, provided it attains (as has not yet occurred) to a generality which neither reduces nor crushes me. Hence it was necessary to take a look for myself.

I decided then to take as a guide for my new analysis the attraction I felt for certain photographs. For of this attraction, at least, I was certain. What to call it? Fascination? No, this photograph which I pick out and which I love has nothing in common with the

shiny point which sways before your eyes and makes your

head swim; what it produces in me is the very opposite of hebetude; something more like an internal agitation, an excitement, a certain labor too, the pressure of the unspeakable which wants to be spoken. Well, then? Interest? Of brief duration; I have no need to question my feelings in order to list the various reasons to be interested in a photograph; one can either desire the object, the landscape, the body it represents; or love or have loved the being it permits us to recognize; or be astonished by what one sees; or else admire or dispute the photographer's performance, etc.; but these interests are slight, heterogeneous; a certain photograph can satisfy one of them and interest me slightly; and if another photograph interests me powerfully, I should like to know what there is in it that sets me off. So it seemed that the best word to designate (temporarily) the attraction certain photographs exerted upon me was advenience or even adventure. This picture advenes, that one doesn't.

The principle of adventure allows me to make Photography exist. Conversely, without adventure, no photograph. I quote Sartre: "Newspaper photographs can very well 'say nothing to me.' In other words, I look at them without assuming a posture of existence. Though the persons whose photograph I see are certainly present in the photograph, they are so without existential posture, like the Knight and Death present in Dürer's engraving, but without my positing them. Moreover, cases occur where the photograph leaves me so indifferent that I do not even bother to see it 'as an image.' The photograph is vaguely constituted as an object, and the persons who figure there are certainly constituted as persons, but only because of their resemblance to human beings, without any special intentionality. They drift between the shores of perception, between sign and image, without ever approaching either."

In this glum desert, suddenly a specific photograph reaches me; it animates me, and I animate it. So that is how I must name the attraction which makes it exist: an animation. The photograph itself is in no way animated (I do not believe in "lifelike" photographs), but it animates me: this is what creates every adventure.

In this investigation of Photography, I borrowed something from phenomenology's project and something from its language. But it was a vague, casual, even cynical phenomenology, so readily did it agree to distort or to evade its principles according to the whim of my analysis. First of all, I did not escape, or try to escape, from a paradox: on the one hand the desire to give a name to Photography's essence and then to sketch an eidetic science of the Photograph; and on the other the intractable feeling that Photography is essentially (a contradiction in terms) only contingency, singularity, risk: my photographs would always participate, as Lyotard says, in "something or other": is it not the very weakness of Photography, this difficulty in existing which we call banality? Next, my phenomenology agreed to compromise with a power, affect; affect was what I didn't want to reduce; being irreducible, it was thereby what I wanted, what I ought to reduce the Photograph to; but could I retain an affective intentionality, a view of the object which was immediately steeped in desire, repulsion, nostalgia, euphoria? Classical phenomenology, the kind I had known in my adolescence (and there has not been any other since), had never, so far as I could remember, spoken of desire or of mourning. Of course I could make out in Photography, in a very orthodox manner, a whole network of essences: material essences (necessitating the physical, chemical, optical study of the Photography), and regional essences (deriving, for instance, from aesthetics, from History, from sociology); but at the moment of reaching the essence of Photography in general, I branched off; instead of following the path of a formal ontology (of a Logic), I stopped, keeping with me, like a treasure, my desire or my grief; the anticipated essence of the Photograph could not, in my mind, be separated from the "pathos" of which, from the first glance, it consists. I was like that friend who had turned to Photography only because it allowed him to photograph his son. As Spectator I was interested in Photography only for "sentimental" reasons; I wanted to explore it not as a question (a theme) but as a wound: I see, I feel, hence I notice, I observe, and I think.

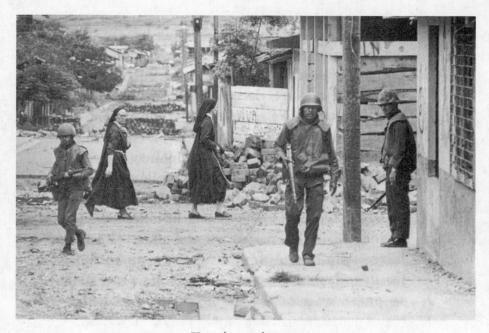

"I understood at once that this photograph's 'adventure' derived from the co-presence of two elements . . ."

KOEN WESSING: NICARAGUA. 1979

A photograph made me pause. Nothing very extraordinary: the (photographic) banality of a rebellion in Nicaragua: a ruined street, two helmeted soldiers on patrol; behind them, two nuns. Did this photograph please me? Interest me? Intrigue me? Not even. Simply, it existed (for me). I understood at once that its existence (its "adventure") derived from the co-presence of two discontinuous elements, heterogeneous in that they did not belong to the same world (no need to proceed to the point of contrast): the soldiers and the nuns. I foresaw a structural rule (conforming to my own observation), and I immediately tried to verify it by inspecting other photographs by the same reporter (the Dutchman Koen Wessing): many of them attracted me because they included this kind of duality which I had just become aware of. Here a mother and daughter sob over the father's arrest (Baudelaire: "the emphatic truth of gesture in the great circumstances of life"), and this happens out in the countryside (where could they have learned the news? for whom are these gestures?). Here, on a torn-up pavement, a child's corpse under a white sheet; parents and friends stand around it, desolate: a banal enough scene, unfortunately, but I noted certain interferences: the corpse's one bare foot, the sheet carried by the weeping mother (why this sheet?), a woman in the background,

I was glancing through an illustrated magazine.

23

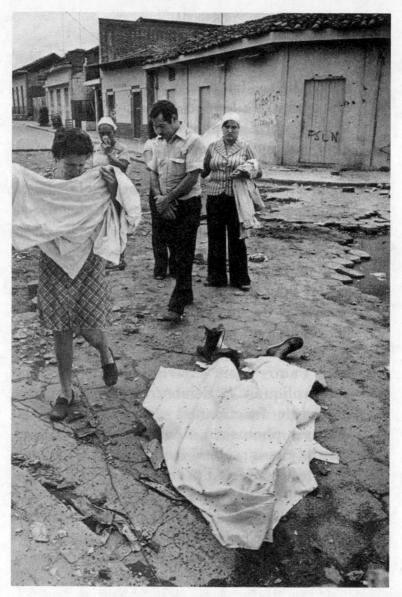

"... the sheet carried by the weeping mother (why this sheet?)..."

Koen Wessing: Nicaragua. 1979

probably a friend, holding a handkerchief to her nose. Here again, in a bombed-out apartment, the huge eyes of two little boys, one's shirt raised over his little belly (the excess of those eyes disturb the scene). And here, finally, leaning against the wall of a house, three Sandinists, the lower part of their faces covered by a rag (stench? secrecy? I have no idea, knowing nothing of the realities of guerrilla warfare); one of them holds a gun that rests on his thigh (I can see his nails); but his other hand is stretched out, open, as if he were explaining and demonstrating something. My rule applied all the more closely in that other pictures from the same reportage were less interesting to me; they were fine shots, they expressed the dignity and horror of rebellion, but in my eyes they bore no mark or sign: their homogeneity remained cultural: they were "scenes," rather à la Greuze, had it not been for the harshness of the subject.

My rule was plausible enough for me to try to name (as I would need to do) these two elements whose co-presence established, it seemed, the particular interest I took in these photographs.

The first, obviously, is an extent, it has the extension of a field, which I perceive quite familiarly as a consequence of my knowledge, my culture; this field can be more or less stylized, more or less successful, depending on the photographer's skill or luck, but it always refers to a clas-

125

sical body of information: rebellion, Nicaragua, and all the signs of both: wretched un-uniformed soldiers, ruined streets, corpses, grief, the sun, and the heavy-lidded Indian eyes. Thousands of photographs consist of this field. and in these photographs I can, of course, take a kind of general interest, one that is even stirred sometimes, but in regard to them my emotion requires the rational intermediary of an ethical and political culture. What I feel about these photographs derives from an average affect, almost from a certain training. I did not know a French word which might account for this kind of human interest. but I believe this word exists in Latin: it is studium, which doesn't mean, at least not immediately, "study," but application to a thing, taste for someone, a kind of general, enthusiastic commitment, of course, but without special acuity. It is by studium that I am interested in so many photographs, whether I receive them as political testimony or enjoy them as good historical scenes: for it is culturally (this connotation is present in studium) that I participate in the figures, the faces, the gestures, the settings, the actions.

The second element will break (or punctuate) the *studium*. This time it is not I who seek it out (as I invest the field of the *studium* with my sovereign consciousness), it is this element which rises from the scene, shoots out of it like an arrow, and pierces me. A Latin word exists to designate this wound, this prick, this mark made by a pointed instrument: the word suits me all the better in that it also refers to the notion of punctuation, and because the photographs I am speaking of are in effect punc-

tuated, sometimes even speckled with these sensitive points; precisely, these marks, these wounds are so many points. This second element which will disturb the studium I shall therefore call punctum; for punctum is also: sting, speck, cut, little hole-and also a cast of the dice. A photograph's punctum is that accident which pricks me (but also bruises me, is poignant to me).

Having thus distinguished two themes in Photography (for in general the photographs I liked were constructed in the manner of a classical sonata), I could occupy myself with one after the other.

Many photographs are, alas, inert under my gaze. But even among those which have some existence in my eyes, most provoke only a general and, so to speak, polite interest: they have no punctum in them: they please or displease me without pricking me: they are invested with no more than studium.

The studium is that very wide field of unconcerned desire, of various interest, of inconsequential taste: I like / I don't like. The studium is of the order of liking, not of loving; it mobilizes a half desire, a demi-volition; it is the same sort of vague, slippery, irresponsible interest one takes in the people, the entertainments, the books, the clothes one finds "all right."

To recognize the studium is inevitably to encounter the photographer's intentions, to enter into harmony with

them, to approve or disapprove of them, but always to understand them, to argue them within myself, for culture (from which the studium derives) is a contract arrived at between creators and consumers. The studium is a kind of education (knowledge and civility, "politeness") which allows me to discover the Operator, to experience the intentions which establish and animate his practices, but to experience them "in reverse," according to my will as a Spectator. It is rather as if I had to read the Photographer's myths in the Photograph, fraternizing with them but not quite believing in them. These myths obviously aim (this is what myth is for) at reconciling the Photograph with society (is this necessary? -Yes, indeed: the Photograph is dangerous) by endowing it with functions, which are, for the Photographer, so many alibis. These functions are: to inform, to represent, to surprise, to cause to signify, to provoke desire. And I, the Spectator, I recognize them with more or less pleasure: I invest them with my studium (which is never my delight or my pain).

Since the Photograph is pure contingency and can be nothing else (it is always something that is represented)—contrary to the text which, by the sudden action of a single word, can shift a sentence from description to reflection-it immediately yields up those "details" which constitute the very raw material of ethnological knowledge. When William Klein

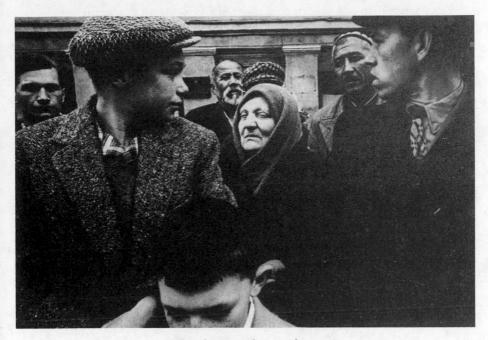

"The photographer teaches me how the Russians dress: I note a boy's big cloth cap, another's necktie, an old woman's scarf around her head, a youth's haircut . . ."

William Klein: Mayday, Moscow. 1959

photographs "Mayday, 1959" in Moscow, he teaches me how Russians dress (which after all I don't know): I note a boy's big cloth cap, another's necktie, an old woman's scarf around her head, a youth's haircut, etc. I can enter still further into such details, observing that many of the men photographed by Nadar have long fingernails: an ethnographical question: how long were nails worn in a certain period? Photography can tell me this much better than painted portraits. It allows me to accede to an infra-knowledge; it supplies me with a collection of partial objects and can flatter a certain fetishism of mine: for this "me" which likes knowledge, which nourishes a kind of amorous preference for it. In the same way, I like certain biographical features which, in a writer's life, delight me as much as certain photographs; I have called these features "biographemes"; Photography has the same relation to History that the biographeme has to biography.

The first man who saw the first photograph (if we except Niepce, who made it) must have thought it was a painting: same framing,

same perspective. Photography has been, and is still, tormented by the ghost of Painting (Mapplethorpe represents an iris stalk the way an Oriental painter might have done it); it has made Painting, through its copies and contestations, into the absolute, paternal Reference, as if it were born from the Canvas (this is true, technically, but only in part; for the painters' *camera obscura* is only one of the causes of Photography; the essential one, perhaps, was the chemical discovery). At this point in my investigation, nothing eidetically distinguishes a photograph, however realistic, from a painting. "Pictorialism" is only an exaggeration of what the Photograph thinks of itself.

Yet it is not (it seems to me) by Painting that Photography touches art, but by Theater. Niepce and Daguerre are always put at the origin of Photography (even if the latter has somewhat usurped the former's place); now Daguerre, when he took over Niepce's invention, was running a panorama theater animated by light shows and movements in the Place du Château. The camera obscura, in short, has generated at one and the same time perspective painting, photography, and the diorama, which are all three arts of the stage; but if Photography seems to me closer to the Theater, it is by way of a singular intermediary (and perhaps I am the only one who sees it): by way of Death. We know the original relation of the theater and the cult of the Dead: the first actors separated themselves from the community by playing the role of the Dead: to make oneself up was to designate oneself as a body simultaneously living and dead: the whitened bust of the totemic theater, the man with the painted face in the Chinese theater, the rice-paste makeup of the Indian Katha-Kali, the Japanese No mask . . . Now it is this same relation which I find in the Photograph; however "lifelike" we strive to make it (and this frenzy to be lifelike can only be our mythic denial of an apprehension of death), Photography is a kind of primitive theater, a kind of *Tableau Vivant*, a figuration of the motionless and made-up face beneath which we see the dead.

I imagine (this is all I can do, since I am not a photographer) that the essential gesture of the *Operator* is to surprise something or someone

(through the little hole of the camera), and that this gesture is therefore perfect when it is performed unbeknownst to the subject being photographed. From this gesture derive all photographs whose principle (or better, whose alibi) is "shock"; for the photographic "shock" (quite different from the *punctum*) consists less in traumatizing than in revealing what was so well hidden that the actor himself was unaware or unconscious of it. Hence a whole gamut of "surprises" (as they are for me, the *Spectator*; but for the Photographer, these are so many "performances").

The first surprise is that of the "rare" (rarity of the referent, of course); a photographer, we are told admiringly, has spent four years composing a photographic anthology of monsters (man with two heads, woman with three breasts, child with a tail, etc.: all smiling). The second surprise is one habitual to Painting, which has frequently reproduced a gesture apprehended at the point in its course where the normal eye cannot arrest it (I have elsewhere called this gesture the numen of historical painting): Bonaparte has just touched the plague victims of Jaffa; his hand withdraws; in the same way, taking advantage of its instantaneous action, the Photograph immobilizes a rapid scene in its decisive instant: Apestéguy, during the Publicis fire, photographs a woman jumping out of a window. The third surprise is that of prowess: "For fifty years, Harold D. Edgerton has photographed the explosion of a drop of milk, to the millionth of a second" (little need to admit that this kind of photography neither touches nor even interests me: I am too much of a phenomenologist to like anything but appearances to my own measure). A fourth surprise is the one which the photographer looks for from the contortions of technique: superimpressions, anamorphoses, deliberate exploitation of certain defects (blurring, deceptive perspectives, trick framing); great photographers (Germaine Krull, Kertész, William Klein) have played on these surprises, without convincing me, even if I understand their subversive bearing. Fifth type of surprise: the trouvaille or lucky find; Kertész photographs the window of a mansard roof; behind the pane, two classical busts look out into the street (I like Kertész, but I don't like whimsy, neither in music nor in photography); the scene can be arranged by the photographer, but in the world of illustrated media, it is a "natural" scene which the good reporter has had the genius, i.e., the luck, to catch: an emir in native costume on skis.

All these surprises obey a principle of defiance (which is why they are alien to me): the photographer, like an

acrobat, must defy the laws of probability or even of possibility; at the limit, he must defy those of the interesting: the photograph becomes "surprising" when we do not know why it has been taken; what motive and what interest is there in photographing a backlighted nude in a doorway, the front of an old car in the grass, a freighter at the dock, two benches in a field, a woman's buttocks at a farmhouse window, an egg on a naked belly (photographs awarded prizes at a contest for amateurs)? In an initial period, Photography, in order to surprise, photographs the notable; but soon, by a familiar reversal, it decrees notable whatever it photographs. The "anything whatever" then becomes the sophisticated acme of value.

Since every photograph is contingent (and thereby outside of meaning), Photography cannot signify (aim at a generality) except by assuming a mask. It is this word which Calvino correctly uses to designate what makes a face into the product of a society and of its history. As in the portrait of William Casby, photographed by Avedon: the essence of slavery is here laid bare: the mask is the meaning, insofar as it is absolutely pure (as it was in the ancient theater). This is why the great portrait photographers are great mythologists: Nadar (the French bourgeoisie), Sander (the Germans of pre-Nazi Germany), Avedon (New York's "upper crust").

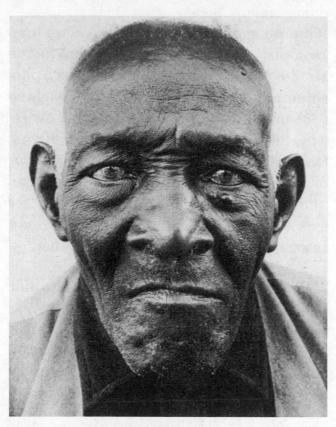

"The mask is meaning, insofar as it is absolutely pure . . . "

R. Avedon: William Casby, Born a Slave. 1963

Yet the mask is the difficult region of Photography. Society, it seems, mistrusts pure meaning: It wants meaning, but at the same time it wants this meaning to be surrounded by a noise (as is said in cybernetics) which will make it less acute. Hence the photograph whose meaning (I am not saying its effect, but its meaning) is too impressive is quickly deflected; we consume it aesthetically, not politically. The Photograph of the Mask is in fact critical enough to disturb (in 1934, the Nazis censored Sander because his "faces of the period" did not correspond to the Nazi archetype of the race), but it is also too discreet (or too "distinguished") to constitute an authentic and effective social critique, at least according to the exigencies of militantism: what committed science would acknowledge the interest of Physiognomy? Is not the very capacity to perceive the political or moral meaning of a face a class deviation? And even this is too much to say: Sander's Notary is suffused with self-importance and stiffness, his Usher with assertiveness and brutality; but no notary, no usher could ever have read such signs. As distance, social observation here assumes the necessary intermediary role in a delicate aesthetic, which renders it futile: no critique except among those who are already capable of criticism. This impasse is something like Brecht's: he was hostile to Photography because (he said) of the weakness of its critical power; but his own theater has never been able to be politically effective on account of its subtlety and its aesthetic quality.

If we except the realm of Advertising, where the meaning must be clear and distinct only by reason of its mer-

"The Nazis censored Sander because his 'faces of the period' did not correspond to the aesthetic of the Nazi race."

SANDER: NOTARY

cantile nature, the semiology of Photography is therefore limited to the admirable performances of several portraitists. For the rest, with regard to the heterogeneity of "good" photographs, all we can say is that the *object speaks*, it induces us, vaguely, to think. And further: even this risks being perceived as dangerous. At the limit, *no meaning at all* is safer: the editors of *Life* rejected Kertész's photographs when he arrived in the United States in 1937 because, they said, his images "spoke too much"; they made us reflect, suggested a meaning—a different meaning from the literal one. Ultimately, Photography is subversive not when it frightens, repels, or even stigmatizes, but when it is *pensive*, when it thinks.

An old house, a shadowy porch, tiles, a crumbling Arab decoration, a man sitting against the wall, a deserted street, a Mediterranean tree (Charles Clifford's "Alhambra"): this old photograph (1854) touches me: it is quite simply *there* that I should like to live. This desire affects me at a depth and according to roots which I do not know: warmth of the climate? Mediterranean myth? Apollinism? Defection? Withdrawal? Anonymity? Nobility? Whatever the case (with regard to myself, my motives, my fantasy), I want to live there, *en finesse*—and the tourist photograph never satisfies that *esprit de finesse*. For me, photographs of landscape (urban or country) must be *habitable*, not visitable.

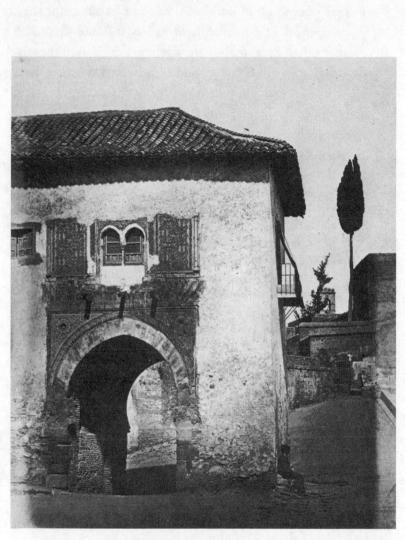

"I want to live there . . . "

Charles Clifford: The Alhambra (Grenada). 1854–1856

This longing to inhabit, if I observe it clearly in myself, is neither oneiric (I do not dream of some extravagant site) nor empirical (I do not intend to buy a house according to the views of a real-estate agency); it is fantasmatic, deriving from a kind of second sight which seems to bear me forward to a utopian time, or to carry me back to somewhere in myself: a double movement which Baudelaire celebrated in Invitation au voyage and La Vie antérieure. Looking at these landscapes of predilection, it is as if I were certain of having been there or of going there. Now Freud says of the maternal body that "there is no other place of which one can say with so much certainty that one has already been there." Such then would be the essence of the landscape (chosen by desire): heimlich, awakening in me the Mother (and never the disturbing Mother).

Having thus reviewed the *docile interests* which certain photographs awaken in me, I deduced that the *studium*, insofar as it is not traversed, lashed, striped by a detail (*punctum*) which attracts or distresses me, engenders a very widespread type of photograph (the most widespread in the world), which we might call the *unary photograph*. In generative grammar, a transformation is unary if, through it, a single series is generated by the base: such are the passive, negative, interrogative, and emphatic transformations. The Photograph is unary when it emphatically transforms "reality" without doubling it, without making it vacillate (emphasis is a power of cohesion): no duality, no indirection, no disturbance. The unary Photograph has every reason to be banal, "unity" of composition being the first rule of vulgar (and notably, of academic) rhetoric: "The subject," says one handbook for amateur photographers, "must be simple, free of useless accessories; this is called the Search for Unity."

News photographs are very often unary (the unary photograph is not necessarily tranquil). In these images, no *punctum*: a certain shock—the literal can traumatize —but no disturbance; the photograph can "shout," not wound. These journalistic photographs are received (all at once), perceived. I glance through them, I don't recall them; no detail (in some corner) ever interrupts my reading: I am interested in them (as I am interested in the world), I do not love them.

Another unary photograph is the pornographic photograph (I am not saying the erotic photograph: the erotic is a pornographic that has been disturbed, fissured). Nothing more homogeneous than a pornographic photograph. It is always a naïve photograph, without intention and without calculation. Like a shop window which shows only one illuminated piece of jewelry, it is completely constituted by the presentation of only one thing: sex: no secondary, untimely object ever manages to half conceal, delay, or distract . . . A proof *a contrario*: Mapplethorpe

/41

shifts his close-ups of genitalia from the pornographic to the erotic by photographing the fabric of underwear at very close range: the photograph is no longer unary, since I am interested in the texture of the material.

In this habitually unary space, occasionally (but alas all too rarely) a "detail" attracts me. I feel that its mere presence changes my reading, that I am looking at a new photograph, marked in my eyes with a higher value. This "detail" is the *punctum*.

It is not possible to posit a rule of connection between the studium and the punctum (when it happens to be there). It is a matter of a co-presence, that is all one can say: the nuns "happened to be there," passing in the background, when Wessing photographed the Nicaraguan soldiers; from the viewpoint of reality (which is perhaps that of the Operator), a whole causality explains the presence of the "detail": the Church implanted in these Latin-American countries, the nuns allowed to circulate as nurses, etc.; but from my Spectator's viewpoint, the detail is offered by chance and for nothing; the scene is in no way "composed" according to a creative logic; the photograph is doubtless dual, but this duality is the motor of no "development," as happens in classical discourse. In order to perceive the *punctum*, no analysis would be of any use to me (but perhaps memory sometimes would, as we shall see): it suffices that the image be large enough, that I do not have to study it (this would be of no help at all), that, given right there on the page, I should receive it right here in my eyes.

Very often the *Punctum* is a "detail," *i.e.*, a partial object. Hence, to give examples of *punctum* is, in a certain fashion, to give myself up.

Here is a family of American blacks, photographed in 1926 by James Van der Zee. The studium is clear: I am sympathetically interested, as a docile cultural subject, in what the photograph has to say, for it speaks (it is a "good" photograph): it utters respectability, family life, conformism, Sunday best, an effort of social advancement in order to assume the White Man's attributes (an effort touching by reason of its naïveté). The spectacle interests me but does not prick me. What does, strange to say, is the belt worn low by the sister (or daughter)-the "solacing Mammy"-whose arms are crossed behind her back like a schoolgirl, and above all her strapped pumps (Mary Janes-why does this dated fashion touch me? I mean: to what date does it refer me?). This particular punctum arouses great sympathy in me, almost a kind of tenderness. Yet the *punctum* shows no preference for morality or good taste: the punctum can be ill-bred. William Klein has photographed children of Little Italy in New York

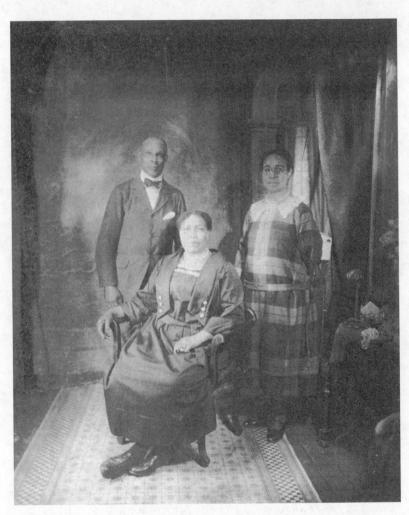

The strapped pumps

James Van der Zee: Family Portrait. 1926

(1954); all very touching, amusing, but what I stubbornly see are one child's bad teeth. Kertész, in 1926, took young Tzara's portrait (with a monocle); but what I notice, by that additional vision which is in a sense the gift, the grace of the *punctum*, is Tzara's hand resting on the door frame: a large hand whose nails are anything but clean.

However lightning-like it may be, the *punctum* has, more or less potentially, a power of expansion. This power is often metonymic. There is a photograph by Kertész (1921) which shows a blind gypsy violinist being led by a boy; now what I see, by means of this "thinking eye" which makes me add something to the photograph, is the dirt road; its texture gives me the certainty of being in Central Europe; I perceive the referent (here, the photograph really transcends itself: is this not the sole proof of its art? To annihilate itself as *medium*, to be no longer a sign but the thing itself?), I recognize, with my whole body, the straggling villages I passed through on my longago travels in Hungary and Rumania.

There is another (less Proustian) expansion of the *punctum*: when, paradoxically, while remaining a "detail," it fills the whole picture. Duane Michals has photographed Andy Warhol: a provocative portrait, since Warhol hides his face behind both hands. I have no desire to comment intellectually on this game of hide-and-seek (which belongs to the *Studium*); since for me, Warhol hides nothing; he offers his hands to read, quite openly; and the *punctum* is not the gesture but the slightly repellent substance of those spatulate nails, at once soft and hard-edged.

145

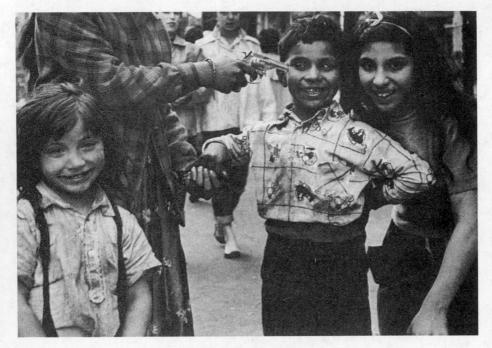

"What I stubbornly see are one boy's bad teeth"

William Klein: Little Italy. New York, 1954

20 Certain details may "prick" me. If they do not, it is doubtless because the photographer has put them there intentionally. In William Klein's "Shinohiera, Fighter Painter" (1961), the character's monstrous head has nothing to say to me because I can see so clearly that it is an artifice of the camera angle. Some soldiers with nuns behind them served as an example to explain what the punctum was for me (here, quite elementary); but when Bruce Gilden photographs a nun and some drag queens together (New Orleans, 1973), the deliberate (not to say, rhetorical) contrast produces no effect on me, except perhaps one of irritation. Hence the detail which interests me is not, or at least is not strictly, intentional, and probably must not be so; it occurs in the field of the photographed thing like a supplement that is at once inevitable and delightful; it does not necessarily attest to the photographer's art; it says only that the photographer was there, or else, still more simply, that he could not not photograph the partial object at the same time as the total object (how could Kertész have "separated" the dirt road from the violinist walking on it?). The Photographer's "second sight" does not consist in "seeing" but in being there. And above all, imitating Orpheus, he must not turn back to look at what he is leading-what he is giving to me!

"I recognize, with my whole body, the straggling villages I passed through on my long-ago travels in Hungary and Rumania..."

A. Kertész: The Violinist's Tune. Abony, Hungary, 1921

21 A detail overwhelms the entirety of my read-ing; it is an intense mutation of my interest, A detail overwhelms the entirety of my reada fulguration. By the mark of something, the photograph is no longer "anything whatever." This something has triggered me, has provoked a tiny shock, a satori, the passage of a void (it is of no importance that its referent is insignificant). A strange thing: the virtuous gesture which seizes upon "docile" photographs (those invested by a simple studium) is an idle gesture (to leaf through, to glance quickly and desultorily, to linger, then to hurry on); on the contrary, the reading of the punctum (of the pricked photograph, so to speak) is at once brief and active. A trick of vocabulary: we say "to develop a photograph"; but what the chemical action develops is undevelopable, an essence (of a wound), what cannot be transformed but only repeated under the instances of insistence (of the insistent gaze). This brings the Photograph (certain photographs) close to the Haiku. For the notation of a haiku, too, is undevelopable: everything is given, without provoking the desire for or even the possibility of a rhetorical expansion. In both cases we might (we must) speak of an intense immobility: linked to a detail (to a detonator), an explosion makes a little star on the pane of the text or of the photograph: neither the Haiku nor the Photograph makes us "dream."

In Ombredane's experiment, the blacks see on his

"I dismiss all knowledge, all culture . . . I see only the boy's huge Danton collar, the girl's finger bandage . . ."

Lewis H. Hine: Idiot Children in an Institution. New Jersey, 1924 screen only the chicken crossing one corner of the village square. I too, in the photograph of two retarded children at an institution in New Jersey (taken in 1924 by Lewis H. Hine), hardly see the monstrous heads and pathetic profiles (which belong to the *studium*); what I see, like Ombredane's blacks, is the off-center detail, the little boy's huge Danton collar, the girl's finger bandage; I am a primitive, a child—or a maniac; I dismiss all knowledge, all culture, I refuse to inherit anything from another eye than my own.

The *studium* is ultimately always coded, the *punctum* is not (I trust I am not using these words abusively). Nadar, in his time (1882),

photographed Savorgnan de Brazza between two young blacks dressed as French sailors; one of the two boys, oddly, has rested his hand on Brazza's thigh; this incongruous gesture is bound to arrest my gaze, to constitute a *punctum*. And yet it is not one, for I immediately code the posture, whether I want to or not, as "aberrant" (for me, the *punctum* is the other boy's crossed arms). What I can name cannot really prick me. The incapacity to name is a good symptom of disturbance. Mapplethorpe has photographed Robert Wilson and Philip Glass. Wilson *holds* me, though I cannot say why, *i.e.*, say *where*: is it the eyes, the skin, the position of the hands, the track shoes? The effect is certain but unlocatable, it does not find its sign, its

"The punctum, for me, is the second boy's crossed arms . . . "

Nadar: Savorgnan de Brazza. 1882

name; it is sharp and yet lands in a vague zone of myself; it is acute yet muffled, it cries out in silence. Odd contradiction: a floating flash.

Nothing surprising, then, if sometimes, despite its clarity, the *punctum* should be revealed only after the fact, when the photograph is no longer in front of me and I think back on it. I may know better a photograph I remember than a photograph I am looking at, as if direct vision oriented its language wrongly, engaging it in an effort of description which will always miss its point of effect, the punctum. Reading Van der Zee's photograph, I thought I had discerned what moved me: the strapped pumps of the black woman in her Sunday best; but this photograph has worked within me, and later on I realized that the real *punctum* was the necklace she was wearing; for (no doubt) it was this same necklace (a slender ribbon of braided gold) which I had seen worn by someone in my own family, and which, once she died, remained shut up in a family box of old jewelry (this sister of my father never married, lived with her mother as an old maid, and I had always been saddened whenever I thought of her dreary life). I had just realized that however immediate and incisive it was, the punctum could accommodate a certain latency (but never any scrutiny).

Ultimately—or at the limit—in order to see a photograph well, it is best to look away or close your eyes. "The necessary condition for an image is sight," Janouch told Kafka; and Kafka smiled and replied: "We photograph things in order to drive them out of our minds. My stories are a way of shutting my eyes." The photograph must be

153

"Bob Wilson holds me, but I cannot say why . . . "

R. MAPPLETHORPE: PHIL GLASS AND BOB WILSON

silent (there are blustering photographs, and I don't like them): this is not a question of discretion, but of music. Absolute subjectivity is achieved only in a state, an effort, of silence (shutting your eyes is to make the image speak in silence). The photograph touches me if I withdraw it from its usual blah-blah: "Technique," "Reality," "Reportage," "Art," etc.: to say nothing, to shut my eyes, to allow the detail to rise of its own accord into affective consciousness.

Last thing about the punctum: whether or not 23 Last thing about the particular it is what I is triggered, it is an addition: it is what I add to the photograph and what is nonetheless

already there. To Lewis Hine's retarded children, I add nothing with regard to the degenerescence of the profile: the code expresses this before I do, takes my place, does not allow me to speak; what I add-and what, of course, is already in the image-is the collar, the bandage. Do I add to the images in movies? I don't think so; I don't have time: in front of the screen, I am not free to shut my eyes; otherwise, opening them again, I would not discover the same image; I am constrained to a continuous voracity; a host of other qualities, but not pensiveness; whence the interest, for me, of the photogram.

Yet the cinema has a power which at first glance the Photograph does not have: the screen (as Bazin has remarked) is not a frame but a hideout; the man or woman

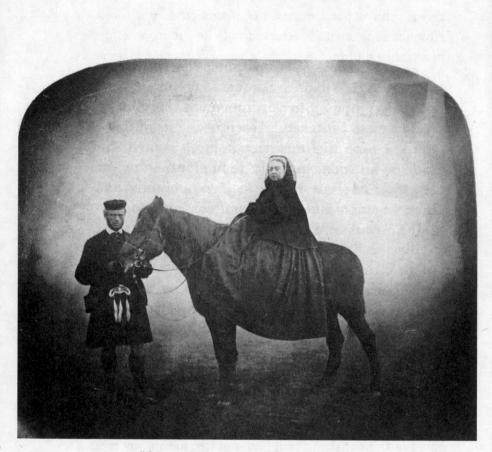

"Queen Victoria, entirely unesthetic . . ." (Virginia Woolf)

G. W. WILSON: QUEEN VICTORIA. 1863

who emerges from it continues living: a "blind field" constantly doubles our partial vision. Now, confronting millions of photographs, including those which have a good studium. I sense no blind field: everything which happens within the frame dies absolutely once this frame is passed beyond. When we define the Photograph as a motionless image, this does not mean only that the figures it represents do not move; it means that they do not emerge, do not leave: they are anesthetized and fastened down, like butterflies. Yet once there is a punctum, a blind field is created (is divined): on account of her necklace, the black woman in her Sunday best has had, for me, a whole life external to her portrait; Robert Wilson, endowed with an unlocatable *punctum*, is someone I want to meet. Here is Queen Victoria photographed in 1863 by George W. Wilson; she is on horseback, her skirt suitably draping the entire animal (this is the historical interest, the studium); but beside her, attracting my eyes, a kilted groom holds the horse's bridle: this is the *punctum*; for even if I do not know just what the social status of this Scotsman may be (servant? equerry?), I can see his function clearly: to supervise the horse's behavior: what if the horse suddenly began to rear? What would happen to the queen's skirt, i.e., to her majesty? The punctum fantastically "brings out" the Victorian nature (what else can one call it?) of the photograph, it endows this photograph with a blind field.

The presence (the dynamics) of this blind field is, I believe, what distinguishes the erotic photograph from the pornographic photograph. Pornography ordinarily repre-

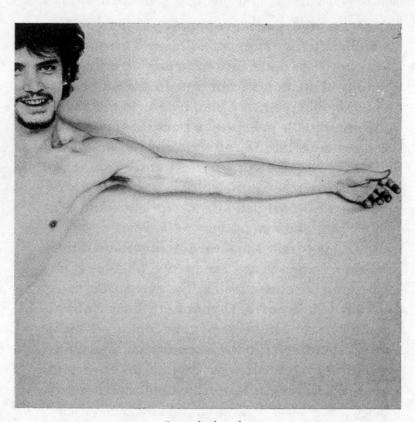

"... the hand at the right degree of openness, the right density of abandonment ..."

R. MAPPLETHORPE: YOUNG MAN WITH ARM EXTENDED

sents the sexual organs, making them into a motionless object (a fetish), flattered like an idol that does not leave its niche; for me, there is no punctum in the pornographic image; at most it amuses me (and even then, boredom follows quickly). The erotic photograph, on the contrary (and this is its very condition), does not make the sexual organs into a central object; it may very well not show them at all; it takes the spectator outside its frame, and it is there that I animate this photograph and that it animates me. The punctum, then, is a kind of subtle beyond -as if the image launched desire beyond what it permits us to see: not only toward "the rest" of the nakedness, not only toward the fantasy of a praxis, but toward the absolute excellence of a being, body and soul together. This boy with his arm outstretched, his radiant smile, though his beauty is in no way classical or academic, and though he is half out of the photograph, shifted to the extreme left of the frame, incarnates a kind of blissful eroticism; the photograph leads me to distinguish the "heavy" desire of pornography from the "light" (good) desire of eroticism; after all, perhaps this is a question of "luck": the photographer has caught the boy's hand (the boy is Mapplethorpe himself, I believe) at just the right degree of openness, the right density of abandonment: a few millimeters more or less and the divined body would no longer have been offered with benevolence (the pornographic body shows itself, it does not give itself, there is no generosity in it): the photographer has found the right moment, the kairos of desire.

Proceeding this way from photograph to photograph (to tell the truth, all of them public ones, up to now), I had perhaps learned how my desire worked, but I had not discovered the nature (the eidos) of Photography. I had to grant that my pleasure was an imperfect mediator, and that a subjectivity reduced to its hedonist project could not recognize the universal. I would have to descend deeper into myself to find the evidence of Photography, that thing which is seen by anyone looking at a photograph and which distinguishes it in his eyes from any other image. I would have to make my recantation, my palinode.

Part Two

Now, one November evening shortly after my mother's death, I was going through some photographs. I had no hope of "finding" her,

I expected nothing from these "photographs of a being before which one recalls less of that being than by merely thinking of him or her" (Proust). I had acknowledged that fatality, one of the most agonizing features of mourning, which decreed that however often I might consult such images, I could never recall her features (summon them up as a totality). No, what I wanted-as Valéry wanted, after his mother's death-was "to write a little compilation about her, just for myself" (perhaps I shall write it one day, so that, printed, her memory will last at least the time of my own notoriety). Further, I could not even say about these photographs, if we except the one I had already published (which shows my mother as a young woman on a beach of Les Landes, and in which I "recognized" her gait, her health, her glow-but not her face, which is too far away), I could not even say that I loved them: I was not sitting down to contemplate them, I was not engulfing myself in them. I was sorting them, but

none seemed to me really "right": neither as a photographic performance nor as a living resurrection of the beloved face. If I were ever to show them to friends I could doubt that these photographs would speak.

With regard to many of these photographs, it

with regard to have a separated me from them. Is History not simply that time when we were not born? I could read my nonexistence in the clothes my mother had worn before I can remember her. There is a kind of stupefaction in seeing a familiar being dressed differently. Here, around 1913, is my mother dressed up -hat with a feather, gloves, delicate linen at wrists and throat, her "chic" belied by the sweetness and simplicity of her expression. This is the only time I have seen her like this, caught in a History (of tastes, fashions, fabrics): my attention is distracted from her by accessories which have perished; for clothing is perishable, it makes a second grave for the loved being. In order to "find" my mother, fugitively alas, and without ever being able to hold on to this resurrection for long, I must, much later, discover in several photographs the objects she kept on her dressing table, an ivory powder box (I loved the sound of its lid), a cut-crystal flagon, or else a low chair, which is now near my own bed, or again, the raffia panels she arranged above the divan, the large bags she loved

(whose comfortable shapes belied the bourgeois notion of the "handbag").

Thus the life of someone whose existence has somewhat preceded our own encloses in its particularity the very tension of History, its division. History is hysterical: it is constituted only if we consider it, only if we look at itand in order to look at it, we must be excluded from it. As a living soul, I am the very contrary of History, I am what belies it, destroys it for the sake of my own history (impossible for me to believe in "witnesses"; impossible, at least, to be one; Michelet was able to write virtually nothing about his own time). That is what the time when my mother was alive before me is-History (moreover, it is the period which interests me most, historically). No anamnesis could ever make me glimpse this time starting from myself (this is the definition of anamnesis)whereas, contemplating a photograph in which she is hugging me, a child, against her, I can waken in myself the rumpled softness of her crêpe de Chine and the perfume of her rice powder.

And here the essential question first appeared: did I *recognize* her?

According to these photographs, sometimes I recognized a region of her face, a certain relation of nose and forehead, the movement of her arms, her hands. I never recognized her except in fragments, which is to say that I missed her being, and that therefore I missed her altogether. It was not she, and yet it was no one else. I would have recognized her among thousands of other women, yet I did not "find" her. I recognized her differentially, not essentially. Photography thereby compelled me to perform a painful labor; straining toward the essence of her identity, I was struggling among images partially true, and therefore totally false. To say, confronted with a certain photograph, "That's almost the way she was!" was more distressing than to say, confronted with another, "That's not the way she was at all." The almost: love's dreadful regime, but also the dream's disappointing status-which is why I hate dreams. For I often dream about her (I dream only about her), but it is never quite my mother: sometimes, in the dream, there is something misplaced, something excessive: for example, something playful or casual-which she never was; or again I know it is she, but I do not see her features (but do we see, in dreams, or do we know?): I dream about her, I do not dream her. And confronted with the photograph, as in the dream, it is the same effort, the same Sisyphean labor: to reascend, straining toward the essence, to climb back down without having seen it, and to begin all over again.

Yet in these photographs of my mother there was always a place set apart, reserved and preserved: the brightness of her eyes. For the moment it was a quite physical luminosity, the photographic trace of a color, the bluegreen of her pupils. But this light was already a kind of mediation which led me toward an essential identity, the genius of the beloved face. And then, however imperfect, each of these photographs manifested the very feeling she must have experienced each time she "let" herself be photographed: my mother "lent" herself to the photograph, fearing that refusal would turn to "attitude"; she triumphed over this ordeal of placing herself in front of the lens (an inevitable action) with discretion (but without a touch of the tense theatricalism of humility or sulkiness); for she was always able to replace a moral value with a higher one—a civil value. She did not struggle with her image, as I do with mine: she did not suppose herself.

There I was, alone in the apartment where she had died, looking at these pictures of my mother, one by one, under the lamp, gradually moving back in time with her, looking for the truth of the face I had loved. And I found it.

The photograph was very old. The corners were blunted from having been pasted into an album, the sepia print had faded, and the picture just managed to show two children standing together at the end of a little wooden bridge in a glassed-in conservatory, what was called a Winter Garden in those days. My mother was five at the time (1898), her brother seven. He was leaning against the bridge railing, along which he had extended one arm; she, shorter than he, was standing a little back, facing the camera; you could tell that the photographer had said, "Step forward a little so we can see you"; she was holding

"Who do you think is the world's greatest photographer?" "Nadar"

NADAR: THE ARTIST'S MOTHER (OR WIFE)

one finger in the other hand, as children often do, in an awkward gesture. The brother and sister, united, as I knew, by the discord of their parents, who were soon to divorce, had posed side by side, alone, under the palms of the Winter Garden (it was the house where my mother was born, in Chennevières-sur-Marne).

I studied the little girl and at last rediscovered my mother. The distinctness of her face, the naïve attitude of her hands, the place she had docilely taken without either showing or hiding herself, and finally her expression, which distinguished her, like Good from Evil, from the hysterical little girl, from the simpering doll who plays at being a grownup-all this constituted the figure of a sovereign innocence (if you will take this word according to its etymology, which is: "I do no harm"), all this had transformed the photographic pose into that untenable paradox which she had nonetheless maintained all her life: the assertion of a gentleness. In this little girl's image I saw the kindness which had formed her being immediately and forever, without her having inherited it from anyone; how could this kindness have proceeded from the imperfect parents who had loved her so badly-in short: from a family? Her kindness was specifically out-of-play, it belonged to no system, or at least it was located at the limits of a morality (evangelical, for instance); I could not define it better than by this feature (among others): that during the whole of our life together, she never made a single "observation." This extreme and particular circumstance, so abstract in relation to an image, was nonetheless present in the face revealed in the photograph I

had just discovered. "Not a just image, just an image," Godard says. But my grief wanted a just image, an image which would be both justice and accuracy—*justesse*: just an image, but a just image. Such, for me, was the Winter Garden Photograph.

For once, photography gave me a sentiment as certain as remembrance, just as Proust experienced it one day when, leaning over to take off his boots, there suddenly came to him his grandmother's true face, "whose living reality I was experiencing for the first time, in an involuntary and complete memory." The unknown photographer of Chennevières-sur-Marne had been the mediator of a truth, as much as Nadar making of his mother (or of his wife-no one knows for certain) one of the loveliest photographs in the world; he had produced a supererogatory photograph which contained more than what the technical being of photography can reasonably offer. Or again (for I am trying to express this truth) this Winter Garden Photograph was for me like the last music Schumann wrote before collapsing, that first Gesang der Frühe which accords with both my mother's being and my grief at her death; I could not express this accord except by an infinite series of adjectives, which I omit, convinced however that this photograph collected all the possible predicates from which my mother's being was constituted and whose suppression or partial alteration, conversely, had sent me back to these photographs of her which had left me so unsatisfied. These same photographs, which phenomenology would call "ordinary" objects, were merely analogical, provoking only her identity, not her truth; but the Winter Garden Photograph was indeed essential, it achieved for me, utopically, *the impossible science of the unique being*.

Nor could I omit this from my reflection: that I had discovered this photograph by moving back through Time. The Greeks entered into Death backward: what they had before them was their past. In the same way I worked back through a life, not my own, but the life of someone I love. Starting from her latest image, taken the summer before her death (so tired, so noble, sitting in front of the door of our house, surrounded by my friends), I arrived, traversing threequarters of a century, at the image of a child: I stare intensely at the Sovereign Good of childhood, of the mother, of the mother-as-child. Of course I was then losing her twice over, in her final fatigue and in her first photograph, for me the last; but it was also at this moment that everything turned around and I discovered her as into herself ... (... eternity changes her, to complete Mallarmé's verse).

This movement of the Photograph (of the order of photographs) I have experienced in reality. At the end of her life, shortly before the moment when I looked through her pictures and discovered the Winter Garden Photograph, my mother was weak, very weak. I lived in her weakness

/71

(it was impossible for me to participate in a world of strength, to go out in the evenings; all social life appalled me). During her illness, I nursed her, held the bowl of tea she liked because it was easier to drink from than from a cup; she had become my little girl, uniting for me with that essential child she was in her first photograph. In Brecht, by a reversal I used to admire a good deal, it is the son who (politically) educates the mother; yet I never educated my mother, never converted her to anything at all; in a sense I never "spoke" to her, never "discoursed" in her presence, for her; we supposed, without saying anything of the kind to each other, that the frivolous insignificance of language, the suspension of images must be the very space of love, its music. Ultimately I experienced her, strong as she had been, my inner law, as my feminine child. Which was my way of resolving Death. If, as so many philosophers have said, Death is the harsh victory of the race, if the particular dies for the satisfaction of the universal, if after having been reproduced as other than himself, the individual dies, having thereby denied and transcended himself, I who had not procreated, I had, in her very illness, engendered my mother. Once she was dead I no longer had any reason to attune myself to the progress of the superior Life Force (the race, the species). My particularity could never again universalize itself (unless, utopically, by writing, whose project henceforth would become the unique goal of my life). From now on I could do no more than await my total, undialectical death.

That is what I read in the Winter Garden Photograph.

30 Something like an essence of the Photograph floated in this particular picture. I therefore decided to "derive" all Photography (its "na-

ture") from the only photograph which assuredly existed for me, and to take it somehow as a guide for my last investigation. All the world's photographs formed a Labyrinth. I knew that at the center of this Labyrinth I would find nothing but this sole picture, fulfilling Nietzsche's prophecy: "A labyrinthine man never seeks the truth, but only his Ariadne." The Winter Garden Photograph was my Ariadne, not because it would help me discover a secret thing (monster or treasure), but because it would tell me what constituted that thread which drew me toward Photography. I had understood that henceforth I must interrogate the evidence of Photography, not from the viewpoint of pleasure, but in relation to what we romantically call love and death.

(I cannot reproduce the Winter Garden Photograph. It exists only for me. For you, it would be nothing but an indifferent picture, one of the thousand manifestations of the "ordinary"; it cannot in any way constitute the visible object of a science; it cannot establish an objectivity, in the positive sense of the term; at most it would interest your *studium*: period, clothes, photogeny; but in it, for you, no wound.) From the beginning, I had determined on a principle for myself: never to reduce myself-as-subject, confronting certain photographs, to the disincarnated, disaffected *socius* which science is concerned with. This principle obliged me to "forget" two institutions: the Family, the Mother.

An unknown person has written me: "I hear you are preparing an album of family photographs" (rumor's extravagant progress). No: neither album nor family. For a long time, the family, for me, was my mother and, at my side, my brother; beyond that, nothing (except the memory of grandparents); no "cousin," that unit so necessary to the constitution of the family group. Besides, how opposed I am to that scientific way of treating the family as if it were uniquely a fabric of constraints and rites: either we code it as a group of immediate allegiances or else we make it into a knot of conflicts and repressions. As if our experts cannot conceive that there are families "whose members love one another."

And no more than I would reduce my family to the Family, would I reduce my mother to the Mother. Reading certain general studies, I saw that they might apply quite convincingly to my situation: commenting on Freud (*Moses and Monotheism*), J. J. Goux explains that Judaism rejected the image in order to protect itself from the risk of worshipping the Mother; and that Christianity, by making possible the representation of the maternal feminine, transcended the rigor of the Law for the sake of the Image-Repertoire. Although growing up in a religionwithout-images where the Mother is not worshipped (Protestantism) but doubtless formed culturally by Catholic art, when I confronted the Winter Garden Photograph I gave myself up to the Image, to the Image-Repertoire. Thus I could understand my generality; but having understood it, invincibly I escaped from it. In the Mother, there was a radiant, irreducible core: my mother. It is always maintained that I should suffer more because I have spent my whole life with her; but my suffering proceeds from who she was; and it is because she was who she was that I lived with her. To the Mother-as-Good, she had added that grace of being an individual soul. I might say, like the Proustian Narrator at his grandmother's death: "I did not insist only upon suffering, but upon respecting the originality of my suffering"; for this originality was the reflection of what was absolutely irreducible in her, and thereby lost forever. It is said that mourning, by its gradual labor, slowly erases pain; I could not, I cannot believe this; because for me, Time eliminates the emotion of loss (I do not weep), that is all. For the rest, everything has remained motionless. For what I have lost is not a Figure (the Mother), but a being; and not a being, but a quality (a soul): not the indispensable, but the irreplaceable. I could live without the Mother (as we all do, sooner or later); but what life remained would be absolutely and entirely unqualifiable (without quality).

175

32 What I had noted at the beginning, in a free and easy manner, under cover of method, *i.e.*, What I had noted at the beginning, in a free that every photograph is somehow co-natural

with its referent, I was rediscovering, overwhelmed by the truth of the image. Henceforth I would have to consent to combine two voices: the voice of banality (to say what everyone sees and knows) and the voice of singularity (to replenish such banality with all the élan of an emotion which belonged only to myself). It was as if I were seeking the nature of a verb which had no infinitive, only tense and mode.

First of all I had to conceive, and therefore if possible express properly (even if it is a simple thing) how Photography's Referent is not the same as the referent of other systems of representation. I call "photographic referent" not the optionally real thing to which an image or a sign refers but the necessarily real thing which has been placed before the lens, without which there would be no photograph. Painting can feign reality without having seen it. Discourse combines signs which have referents, of course, but these referents can be and are most often "chimeras." Contrary to these imitations, in Photography I can never deny that the thing has been there. There is a superimposition here: of reality and of the past. And since this constraint exists only for Photography, we must consider it, by reduction, as the very essence, the noeme of Photography. What I intentionalize in a photograph (we are not yet speaking of film) is neither Art nor Communication, it is Reference, which is the founding order of Photography.

The name of Photography's noeme will therefore be: "That-has-been," or again: the Intractable. In Latin (a pedantry necessary because it illuminates certain nuances), this would doubtless be said: *interfuit*: what I see has been here, in this place which extends between infinity and the subject (*operator* or *spectator*); it has been here, and yet immediately separated; it has been absolutely, irrefutably present, and yet already deferred. It is all this which the verb *intersum* means.

In the daily flood of photographs, in the thousand forms of interest they seem to provoke, it may be that the *noeme "That-bas-been"* is not repressed (a *noeme* cannot be repressed) but experienced with indifference, as a feature which goes without saying. It is this indifference which the Winter Garden Photograph had just roused me from. According to a paradoxical order—since usually we verify things before declaring them "true"—under the effect of a new experience, that of intensity, I had induced the truth of the image, the reality of its origin; I had identified truth and reality in a unique emotion, in which I henceforth placed the nature—the genius—of Photography, since no painted portrait, supposing that it seemed "true" to me, could compel me to believe its referent had really existed.

177

I might put this differently: what founds the nature of Photography is the pose. The phys-ical duration of this pose is of little consequence; even in the interval of a millionth of a second (Edgerton's drop of milk) there has still been a pose, for the pose is not, here, the attitude of the target or even a technique of the Operator, but the term of an "intention" of reading: looking at a photograph, I inevitably include in my scrutiny the thought of that instant, however brief, in which a real thing happened to be motionless in front of the eye. I project the present photograph's immobility upon the past shot, and it is this arrest which constitutes the pose. This explains why the Photograph's noeme deteriorates when this Photograph is animated and becomes cinema: in the Photograph, something has posed in front of the tiny hole and has remained there forever (that is my feeling); but in cinema, something has passed in front of this same tiny hole: the pose is swept away and denied by the continuous series of images: it is a different phenomenology, and therefore a different art which begins here, though derived from the first one.

In Photography, the presence of the thing (at a certain past moment) is never metaphoric; and in the case of animated beings, their life as well, except in the case of photographing corpses; and even so: if the photograph then becomes horrible, it is because it certifies, so to speak,

that the corpse is alive, as corpse: it is the living image of a dead thing. For the photograph's immobility is somehow the result of a perverse confusion between two concepts: the Real and the Live: by attesting that the object has been real, the photograph surreptitiously induces belief that it is alive, because of that delusion which makes us attribute to Reality an absolutely superior, somehow eternal value; but by shifting this reality to the past ("this-has-been"), the photograph suggests that it is already dead. Hence it would be better to say that Photography's inimitable feature (its noeme) is that someone has seen the referent (even if it is a matter of objects) in flesh and blood, or again in person. Photography, moreover, began, historically, as an art of the Person: of identity, of civil status, of what we might call, in all senses of the term, the body's formality. Here again, from a phenomenological viewpoint, the cinema begins to differ from the Photograph; for the (fictional) cinema combines two poses: the actor's "thishas-been" and the role's, so that (something I would not experience before a painting) I can never see or see again in a film certain actors whom I know to be dead without a kind of melancholy: the melancholy of Photography itself (I experience this same emotion listening to the recorded voices of dead singers).

I think again of the portrait of William Casby, "born a slave," photographed by Avedon. The *noeme* here is intense; for the man I see here *has been* a slave: he certifies that slavery has existed, not so far from us; and he certifies this not by historical testimony but by a new, somehow experiential order of proof, although it is the past

which is in question-a proof no longer merely induced: the proof-according-to-St.-Thomas-seeking-to-touch-the-resurrected-Christ. I remember keeping for a long time a photograph I had cut out of a magazine-lost subsequently, like everything too carefully put away-which showed a slave market: the slavemaster, in a hat, standing; the slaves, in loincloths, sitting. I repeat: a photograph, not a drawing or engraving; for my horror and my fascination as a child came from this: that there was a certainty that such a thing had existed: not a question of exactitude, but of reality: the historian was no longer the mediator, slavery was given without mediation, the fact was established without method.

It is often said that it was the painters who invented Photography (by bequeathing it their framing, the Albertian perspective, and the optic of the camera obscura). I say: no, it was the chemists. For the noeme "That-has-been" was possible only on the day when a scientific circumstance (the discovery that silver halogens were sensitive to light) made it possible to recover and print directly the luminous rays emitted by a variously lighted object. The photograph is literally an emanation of the referent. From a real body, which was there, proceed radiations which ultimately touch me, who am here; the duration of the transmission is insignificant; the photograph of the missing being, as Sontag says, will

touch me like the delayed rays of a star. A sort of umbilical cord links the body of the photographed thing to my gaze: light, though impalpable, is here a carnal medium, a skin I share with anyone who has been photographed.

It seems that in Latin "photograph" would be said "imago lucis opera expressa"; which is to say: image revealed, "extracted," "mounted," "expressed" (like the juice of a lemon) by the action of light. And if Photography belonged to a world with some residual sensitivity to myth, we should exult over the richness of the symbol: the loved body is immortalized by the mediation of a precious metal, silver (monument and luxury); to which we might add the notion that this metal, like all the metals of Alchemy, is alive.

Perhaps it is because I am delighted (or depressed) to know that the thing of the past, by its immediate radiations (its luminances), has really touched the surface which in its turn my gaze will touch, that I am not very fond of Color. An anonymous daguerreotype of 1843 shows a man and a woman in a medallion subsequently tinted by the miniaturists on the staff of the photographic studio: I always feel (unimportant what actually occurs) that in the same way, color is a coating applied *later on* to the original truth of the black-and-white photograph. For me, color is an artifice, a cosmetic (like the kind used to paint corpses). What matters to me is not the photograph's "life" (a purely ideological notion) but the certainty that the photographed body touches me with its own rays and not with a superadded light. (Hence the Winter Garden Photograph, however pale, is for me the treasury of rays which emanated from my mother as a child, from her hair, her skin, her dress, her gaze, *on that day*.)

The Photograph does not call up the past (nothing Proustian in a photograph). The effect it produces upon me is not to restore what has been abolished (by time, by distance) but to attest that what I see has indeed existed. Now, this is a strictly scandalous effect. Always the Photograph *astonishes* me, with an astonishment which endures and renews itself, inexhaustibly. Perhaps this astonishment, this persistence reaches down into the religious substance out of which I am molded; nothing for it: Photography has something to do with resurrection: might we not say of it what the Byzantines said of the image of Christ which impregnated St. Veronica's napkin: that it was not made by the hand of man, *acheiropoietos*?

Here are some Polish soldiers resting in a field (Kertész, 1915); nothing extraordinary, except this, which no realist painting would give me, that *they were there*; what I see is not a memory, an imagination, a reconstitution, a piece of Maya, such as art lavishes upon us, but reality in a past state: at once the past and the real. What the Photograph feeds my mind on (though my mind is never satiated by it), by a brief action whose shock cannot drift

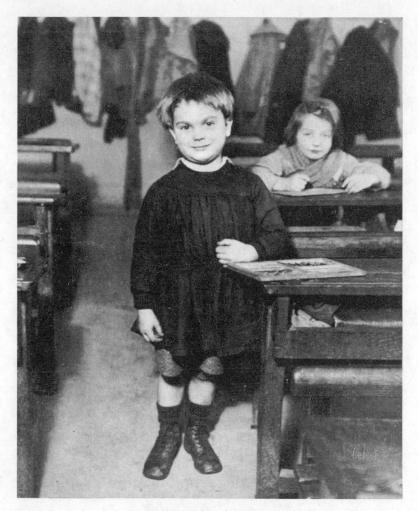

"It is possible that Ernest is still alive today: but where? how? What a novel!"

A. Kertész: Ernest. Paris, 1931

into reverie (this is perhaps the definition of satori), is the simple mystery of concomitance. An anonymous photograph represents a wedding (in England): twenty-five persons of all ages, two little girls, a baby: I read the date and I compute: 1910, so they must all be dead, except perhaps the little girls, the baby (old ladies, an old gentleman now). When I see the beach at Biarritz in 1931 (Lartigue) or the Pont des Arts in 1932 (Kertész), I say to myself: "Maybe I was there"; maybe that's me among the bathers or the pedestrians, one of those summer afternoons when I took the tram from Bayonne to go for a swim on the Grande Plage, or one of those Sunday mornings when, coming from our apartment in the Rue Jacques Callot, I crossed the bridge to go to the Temple de l'Oratoire (Christian phase of my adolescence). The date belongs to the photograph: not because it denotes a style (this does not concern me), but because it makes me lift my head, allows me to compute life, death, the inexorable extinction of the generations: it is possible that Ernest, a schoolboy photographed in 1931 by Kertész, is still alive today (but where? how? What a novel!). I am the reference of every photograph, and this is what generates my astonishment in addressing myself to the fundamental question: why is it that I am alive here and now? Of course, more than other arts, Photography offers an immediate presence to the world-a co-presence; but this presence is not only of a political order ("to participate by the image in contemporary events"), it is also of a metaphysical order. Flaubert derided (but did he really deride?) Bouvard and Pécuchet investigating the sky, the

84/

stars, time, life, infinity, etc. It is this kind of question that Photography raises for me: questions which derive from a "stupid" or simple metaphysics (it is the answers which are complicated): probably the true metaphysics.

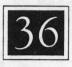

The Photograph does not necessarily say what is no longer, but only and for certain what has been. This distinction is decisive. In front of a

photograph, our consciousness does not necessarily take the nostalgic path of memory (how many photographs are outside of individual time), but for every photograph existing in the world, the path of certainty: the Photograph's essence is to ratify what it represents. One day I received from a photographer a picture of myself which I could not remember being taken, for all my efforts; I inspected the tie, the sweater, to discover in what circumstances I had worn them; to no avail. And yet, *because it was a photograph* I could not deny that I had been *there* (even if I did not know *where*). This distortion between certainty and oblivion gave me a kind of vertigo, something of a "detective" anguish (the theme of *Blow-Up* was not far off); I went to the photographer's show as to a police investigation, to learn at last what I no longer knew about myself.

No writing can give me this certainty. It is the misfortune (but also perhaps the voluptuous pleasure) of language not to be able to authenticate itself. The *noeme*

The first photograph

Niepce: The Dinner Table. Around 1823

of language is perhaps this impotence, or, to put it positively: language is, by nature, fictional; the attempt to render language unfictional requires an enormous apparatus of measurements: we convoke logic, or, lacking that, sworn oath; but the Photograph is indifferent to all intermediaries: it does not invent: it is authentication itself; the (rare) artifices it permits are not probative; they are, on the contrary, trick pictures: the photograph is laborious only when it fakes. It is a prophecy in reverse: like Cassandra, but eyes fixed on the past, Photography never lies: or rather, it can lie as to the meaning of the thing, being by nature tendentious, never as to its existence. Impotent with regard to general ideas (to fiction), its force is nonetheless superior to everything the human mind can or can have conceived to assure us of realitybut also this reality is never anything but a contingency ("so much, no more").

Every photograph is a certificate of presence. This certificate is the new embarrassment which its invention has introduced into the family of images. The first photographs a man contemplated (Niepce in front of the *dinner table*, for instance) must have seemed to him to resemble exactly certain paintings (still the *camera obscura*); he *knew*, however, that he was nose-to-nose with a mutant (a Martian can resemble a man); his consciousness posited the object encountered outside of any analogy, like the ectoplasm of "what-had-been": neither image nor reality, a new being, really: a reality one can no longer touch.

Perhaps we have an invincible resistance to believing in the past, in History, except in the form of myth. The Pho-

87

tograph, for the first time, puts an end to this resistance: henceforth the past is as certain as the present, what we see on paper is as certain as what we touch. It is the advent of the Photograph—and not, as has been said, of the cinema—which divides the history of the world.

It is precisely because the Photograph is an anthropologically new object that it must escape, it seems to me, usual discussions of the image. It is the fashion, nowadays, among Photography's commentators (sociologists and semiologists), to seize upon a semantic relativity: no "reality" (great scorn for the "realists" who do not see that the photograph is always coded), nothing but artifice: Thesis, not Physis; the Photograph, they say, is not an analogon of the world; what it represents is fabricated, because the photographic optic is subject to Albertian perspective (entirely historical) and because the inscription on the picture makes a three-dimensional object into a two-dimensional effigy. This argument is futile: nothing can prevent the Photograph from being analogical; but at the same time, Photography's noeme has nothing to do with analogy (a feature it shares with all kinds of representations). The realists, of whom I am one and of whom I was already one when I asserted that the Photograph was an image without code-even if, obviously, certain codes do inflect our reading of it-the realists do not take the photograph for a "copy" of reality, but for an emanation of past reality: a magic, not an art. To ask whether a photograph is analogical or coded is not a good means of analysis. The important thing is that the photograph possesses an evidential force, and that its testimony bears not on the object but on time. From a phenomenological viewpoint, in the Photograph, the power of authentication exceeds the power of representation.

All the authors concur, Sartre says, in remarking on the poverty of the images which accompany the reading of a novel: if this novel

"takes" me properly, no mental image. To reading's *Dearth-of-Image* corresponds the Photograph's *Totality-of-Image*; not only because it is already an image in itself, but because this very special image gives itself out as complete—*integral*, we might say, playing on the word. The photographic image is full, crammed: no room, nothing can be added to it.

In the cinema, whose raw material is photographic, the image does not, however, have this completeness (which is fortunate for the cinema). Why? Because the photograph, taken in flux, is impelled, ceaselessly drawn toward other views; in the cinema, no doubt, there is always a photographic referent, but this referent shifts, it does not make a claim in favor of its reality, it does not protest its former existence; it does not cling to me: it is not a *specter*. Like the real world, the filmic world is sustained by the presumption that, as Husserl says, "the experience will constantly continue to flow by in the same constitutive style"; but the Photograph breaks the "constitutive style" (this is its astonishment); it is *without future* (this is its pathos, its melancholy); in it, no protensity, whereas the cinema is protensive, hence in no way melancholic (what is it, then? —It is, then, simply "normal," like life). Motionless, the Photograph flows back from presentation to retention.

I can put this another way. Here again is the Winter Garden Photograph. I am alone with it, in front of it. The circle is closed, there is no escape. I suffer, motionless. Cruel, sterile deficiency: I cannot transform my grief, I cannot let my gaze drift; no culture will help me utter this suffering which I experience entirely on the level of the image's finitude (this is why, despite its codes, I cannot read a photograph): the Photograph—my Photograph is without culture: when it is painful, nothing in it can transform grief into mourning. And if dialectic is that thought which masters the corruptible and converts the negation of death into the power to work, then the photograph is undialectical: it is a denatured theater where death cannot "be contemplated," reflected and interiorized; or again: the dead theater of Death, the foreclosure of the Tragic, excludes all purification, all catharsis. I may well worship an Image, a Painting, a Statue, but a photograph? I cannot place it in a ritual (on my desk, in an album) unless, somehow, I avoid looking at it (or avoid its looking at me), deliberately disappointing its unendurable plenitude and, by my very inattention, attaching it to an entirely different class of fetishes: the icons which are kissed in the Greek churches without being seen—on their shiny glass surface.

In the Photograph, Time's immobilization assumes only an excessive, monstrous mode: Time is engorged (whence the relation with the Tableau Vivant, whose mythic prototype is the princess falling asleep in Sleeping Beauty). That the Photograph is "modern," mingled with our noisiest everyday life, does not keep it from having an enigmatic point of inactuality, a strange stasis, the stasis of an arrest (I have read that the inhabitants of the village of Montiel, in the province of Albacete, lived this way, fixated on a time arrested in the past, even while reading newspapers and listening to the radio). Not only is the Photograph never, in essence, a memory (whose grammatical expression would be the perfect tense, whereas the tense of the Photograph is the aorist), but it actually blocks memory, quickly becomes a counter-memory. One day, some friends were talking about their childhood memories; they had any number; but I, who had just been looking at my old photographs, had none left. Surrounded by these photographs, I could no longer console myself with Rilke's line: "Sweet as memory, the mimosas steep the bedroom": the Photograph does not "steep" the bedroom: no odor, no music, nothing but the exorbitant thing. The Photograph is violent: not because it shows violent things, but because on each occasion it fills the sight by force, and because in it nothing can be refused or transformed (that we can sometimes call it mild does not contradict its violence: many say that sugar is mild, but to me sugar is violent, and I call it so).

All those young photographers who are at work in the world, determined upon the capture of actuality, do not know that they are agents of Death. This is the way in which our time assumes Death: with the denying alibi of the distractedly "alive," of which the Photographer is in a sense the professional. For Photography must have some historical relation with what Edgar Morin calls the "crisis of death" beginning in the second half of the nineteenth century; for my part I should prefer that instead of constantly relocating the advent of Photography in its social and economic context, we should also inquire as to the anthropological place of Death and of the new image. For Death must be somewhere in a society; if it is no longer (or less intensely) in religion, it must be elsewhere; perhaps in this image which produces Death while trying to preserve life. Contemporary with the withdrawal of rites, Photography may correspond to the intrusion, in our modern society, of an asymbolic Death, outside of religion, outside of ritual, a kind of abrupt dive into literal Death. Life / Death: the paradigm is reduced to a simple click, the one separating the initial pose from the final print.

With the Photograph, we enter into flat Death. One day, leaving one of my classes, someone said to me with disdain: "You talk about Death very flatly." -As if the horror of Death were not precisely its platitude! The horror is this: nothing to say about the death of one whom I love most, nothing to say about her photograph, which I contemplate without ever being able to get to the heart of it, to transform it. The only "thought" I can have is that at the end of this first death, my own death is inscribed; between the two, nothing more than waiting; I have no other resource than this *irony*: to speak of the "nothing to say."

The only way I can transform the Photograph is into refuse: either the drawer or the wastebasket. Not only does it commonly have the fate of paper (perishable), but even if it is attached to more lasting supports, it is still mortal: like a living organism, it is born on the level of the sprouting silver grains, it flourishes a moment, then ages . . . Attacked by light, by humidity, it fades, weakens, vanishes; there is nothing left to do but throw it away. Earlier societies managed so that memory, the substitute for life, was eternal and that at least the thing which spoke Death should itself be immortal: this was the Monument. But by making the (mortal) Photograph into the general and somehow natural witness of "what has been," modern society has renounced the Monument. A paradox: the same century invented History and Photography. But History is a memory fabricated according to positive formulas, a pure intellectual discourse which abolishes mythic Time; and the Photograph is a certain but fugitive testimony; so that everything, today, prepares our race for this impotence: to be no longer able to conceive duration, affectively or symbolically: the age of the Photograph is also the age of revolutions, contestations, assassinations,

explosions, in short, of impatiences, of everything which denies ripening. —And no doubt, the astonishment of "*that-has-been*" will also disappear. It has already disappeared: I am, I don't know why, one of its last witnesses (a witness of the Inactual), and this book is its archaic trace.

What is it that will be done away with, along with this photograph which yellows, fades, and will someday be thrown out, if not by me—too superstitious for that—at least when I die? Not only "life" (this was alive, this posed live in front of the lens), but also, sometimes—how to put it?—love. In front of the only photograph in which I find my father and mother together, this couple who I know loved each other, I realize: it is love-as-treasure which is going to disappear forever; for once I am gone, no one will any longer be able to testify to this: nothing will remain but an indifferent Nature. This is a laceration so intense, so intolerable, that alone against his century, Michelet conceived of History as love's Protest: to perpetuate not only life but also what he called, in his vocabulary so outdated today, the Good, Justice, Unity, etc.

At the time (at the beginning of this book: already far away) when I was inquiring into my attachment to certain photographs, I thought

I could distinguish a field of cultural interest (the *stud-ium*) from that unexpected flash which sometimes crosses

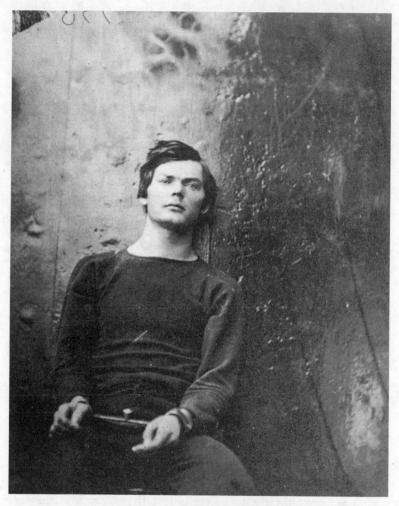

"He is dead and he is going to die . . . "

Alexander Gardner: Portrait of Lewis Payne. 1865

this field and which I called the *punctum*. I now know that there exists another *punctum* (another "stigmatum") than the "detail." This new *punctum*, which is no longer of form but of intensity, is Time, the lacerating emphasis of the *noeme* ("that-has-been"), its pure representation.

In 1865, young Lewis Payne tried to assassinate Secretary of State W. H. Seward. Alexander Gardner photographed him in his cell, where he was waiting to be hanged. The photograph is handsome, as is the boy: that is the *studium*. But the *punctum* is: he is going to die. I read at the same time: This will be and this has been; I observe with horror an anterior future of which death is the stake. By giving me the absolute past of the pose (aorist), the photograph tells me death in the future. What *pricks* me is the discovery of this equivalence. In front of the photograph of my mother as a child, I tell myself: she is going to die: I shudder, like Winnicott's psychotic patient, over a catastrophe which has already occurred. Whether or not the subject is already dead, every photograph is this catastrophe.

This *punctum*, more or less blurred beneath the abundance and the disparity of contemporary photographs, is vividly legible in historical photographs: there is always a defeat of Time in them: *that* is dead and *that* is going to die. These two little girls looking at a primitive airplane above their village (they are dressed like my mother as a child, they are playing with hoops)—how alive they are! They have their whole lives before them; but also they are dead (today), they are then *already* dead (yesterday). At the limit, there is no need to represent a body in order for me to experience this vertigo of time defeated. In 1850, August Salzmann photographed, near Jerusalem, the road to Beith-Lehem (as it was spelled at the time): nothing but stony ground, olive trees; but three tenses dizzy my consciousness: my present, the time of Jesus, and that of the photographer, all this under the instance of "reality"—and no longer through the elaborations of the text, whether fictional or poetic, which itself is never credible *down to the root*.

It is because each photograph always contains this imperious sign of my future death that each

one, however attached it seems to be to the excited world of the living, challenges each of us, one by one, outside of any generality (but not outside of any transcendence). Further, photographs, except for an embarrassed ceremonial of a few boring evenings, are looked at when one is alone. I am uncomfortable during the private projection of a film (not enough of a public, not enough anonymity), but I need to be alone with the photographs I am looking at. Toward the end of the Middle Ages, certain believers substituted for collective reading or collective prayer an individual, under-the-breath prayer, interiorized and meditative (*devotio moderna*). Such, it seems to me, is the regime of *spectatio*. The reading of public photographs is always, at bottom, a private reading. This is obvious for old ("historical") photographs, in which I read a period contemporary with my youth, or with my mother, or beyond, with my grandparents, and into which I project a troubling being, that of the lineage of which I am the final term. But this is also true of the photographs which at first glance have no link, even a metonymic one, with my existence (for instance, all journalistic photographs). Each photograph is read as the private appearance of its referent: the age of Photography corresponds precisely to the explosion of the private into the public, or rather into the creation of a new social value, which is the publicity of the private: the private is consumed as such, publicly (the incessant aggressions of the Press against the privacy of stars and the growing difficulties of legislation to govern them testify to this movement). But since the private is not only one of our goods (falling under the historical laws of property), since it is also the absolutely precious, inalienable site where my image is free (free to abolish itself), as it is the condition of an interiority which I believe is identified with my truth, or, if you like, with the Intractable of which I consist, I must, by a necessary resistance, reconstitute the division of public and private: I want to utter interiority without yielding intimacy. I experience the Photograph and the world in which it participates according to two regions: on one side the Images, on the other my photographs; on one side, unconcern, shifting, noise, the inessential (even if I am abusively deafened by it), on the other the burning, the wounded.

(Usually the amateur is defined as an immature state of the artist: someone who cannot—or will not—achieve the mastery of a profession. But in the field of photographic practice, it is the amateur, on the contrary, who is the assumption of the professional: for it is he who stands closer to the *noeme* of Photography.)

41 If lin

If I like a photograph, if it disturbs me, I linger over it. What am I doing, during the whole time I remain with it? I look at it, I

scrutinize it, as if I wanted to know more about the thing or the person it represents. Lost in the depths of the Winter Garden, my mother's face is vague, faded. In a first impulse, I exclaimed: "There she is! She's really there! At last, there she is!" Now I claim to know-and to be able to say adequately-why, in what she consists. I want to outline the loved face by thought, to make it into the unique field of an intense observation; I want to enlarge this face in order to see it better, to understand it better. to know its truth (and sometimes, naïvely, I confide this task to a laboratory). I believe that by enlarging the detail "in series" (each shot engendering smaller details than at the preceding stage), I will finally reach my mother's very being. What Marey and Muybridge have done as operators I myself want to do as spectator: I decompose, I enlarge, and, so to speak, I retard, in order to have time to know at last. The Photograph justifies this desire, even if it does not satisfy it: I can have the fond hope of discovering truth only because Photography's noeme is

precisely that-has-been, and because I live in the illusion that it suffices to clean the surface of the image in order to accede to what is behind: to scrutinize means to turn the photograph over, to enter into the paper's depth, to reach its other side (what is hidden is for us Westerners more "true" than what is visible). Alas, however hard I look, I discover nothing: if I enlarge, I see nothing but the grain of the paper: I undo the image for the sake of its substance: and if I do not enlarge, if I content myself with scrutinizing, I obtain this sole knowledge, long since possessed at first glance: that this indeed has been: the turn of the screw had produced nothing. In front of the Winter Garden Photograph I am a bad dreamer who vainly holds out his arms toward the possession of the image; I am Golaud exclaiming "Misery of my life!" because he will never know Mélisande's truth. (Mélisande does not conceal, but she does not speak. Such is the Photograph: it cannot say what it lets us see.)

If my efforts are painful, if I am anguished, it is because sometimes I get closer, I am burning: in a certain photograph I believe I per-

ceive the lineaments of truth. This is what happens when I judge a certain photograph "a likeness." Yet on thinking it over, I must ask myself: Who is like what? Resemblance is a conformity, but to what? to an identity. Now this identity is imprecise, even imaginary, to the point where I

"Marceline Desbordes-Valmore reproduces in her face the slightly stupid virtues of her verses . . . "

NADAR: MARCELINE DESBORDES-VALMORE. 1857

can continue to speak of "likeness" without ever having seen the model. As in the case of most of Nadar's portraits (or of Avedon's, today): Guizot is "like" because he conforms to his myth of austerity; Dumas, swollen, beaming, because I already know his self-importance and his fecundity; Offenbach, because I know that his music has something (reputedly) witty about it; Rossini looks false, even crooked (the semblance that resembles); Marceline Desbordes-Valmore reproduces in her face the slightly stupid virtues of her verses; Kropotkin has the bright eyes of anarchizing idealism, etc. I see them all, I can spontaneously call them "likenesses" because they conform to what I expect of them. A proof a contrario: finding myself an uncertain, amythic subject, how could I find myself "like"? All I look like is other photographs of myself, and this to infinity: no one is ever anything but the copy of a copy, real or mental (at most, I can say that in certain photographs I endure myself, or not, depending on whether or not I find myself in accord with the image of myself I want to give). For all its banal appearance (the first thing one says about a portrait), this imaginary analogy is full of extravagance: X shows me the photograph of one of his friends whom he has talked about, whom I have never seen; and yet, I tell myself (I don't know why), "I'm sure Sylvain doesn't look like that." Ultimately a photograph looks like anyone except the person it represents. For resemblance refers to the subject's identity, an absurd, purely legal, even penal affair; likeness gives out identity "as itself," whereas I want a subject -in Mallarmé's terms-"as into itself eternity transforms

it." Likeness leaves me unsatisfied and somehow skeptical (certainly this is the sad disappointment I experience looking at the ordinary photographs of my mother whereas the only one which has given me the splendor of her truth is precisely a lost, remote photograph, one which does not look "like" her, the photograph of a child I never knew).

But more insidious, more penetrating than likeness: the Photograph sometimes makes appear what we never see in a real face (or in a

face reflected in a mirror): a genetic feature, the fragment of oneself or of a relative which comes from some ancestor. In a certain photograph, I have my father's sister's "look." The Photograph gives a little truth, on condition that it parcels out the body. But this truth is not that of the individual, who remains irreducible; it is the truth of lineage. Sometimes I am mistaken, or at least I hesitate: a medallion represents a young woman and her child: surely that is my mother and myself? But no, it is her mother and her son (my uncle); I don't know this so much from the clothes (the etherealized photograph does not show much of them) as from the structure of the face; between my grandmother's face and my mother's there has been the incidence, the flash of the husband, the father, which has refashioned the countenance, and so on down to me (the baby? nothing more neutral). In the

103

The Stock

AUTHOR'S COLLECTION

same way, this photograph of my father as a child: nothing to do with pictures of him as a man; but certain details, certain lineaments connect his face to my grandmother's and to mine-in a sense over his head. Photography can reveal (in the chemical sense of the term), but what it reveals is a certain persistence of the species. According to Léon-Pierre Quint, on the death of the Prince de Polignac (son of Charles X's minister), Proust said that "his face had remained that of his lineage, anterior to his individual soul." The Photograph is like old age: even in its splendor, it disincarnates the face, manifests its genetic essence. Proust (again) said of Charles Haas (the model for Swann), according to George Painter, that he had a short, straight nose, but that old age had turned his skin to parchment, revealing the Iewish nose beneath.

Lineage reveals an identity stronger, more interesting than legal status—more reassuring as well, for the thought of origins soothes us, whereas that of the future disturbs us, agonizes us; but this discovery disappoints us because even while it asserts a permanence (which is the truth of the race, not my own), it bares the mysterious difference of beings issuing from one and the same family: what relation can there be between my mother and her ancestor, so formidable, so monumental, so Hugolian, so much the incarnation of the inhuman distance of the Stock? I must therefore submit to this law: I cannot penetrate, cannot reach into the Photograph. I can only sweep it with my glance, like a smooth surface. The Photograph is *flat*, platitudinous in the true sense of the word, that is what I must acknowledge. It is a mistake to associate Photography, by reason of its technical origins, with the notion of a dark passage (*camera obscura*). It is *camera lucida* that we should say (such was the name of that apparatus, anterior to Photography, which permitted drawing an object through a prism, one eye on the model, the other on the paper); for,

having that absence-as-presence which constitutes the lure and the fascination of the Sirens" (Blanchot). If the Photograph cannot be penetrated, it is because of its evidential power. In the image, as Sartre says, the object yields itself wholly, and our vision of it is *certain* contrary to the text or to other perceptions which give me the object in a vague, arguable manner, and therefore incite me to suspicions as to what I think I am seeing. This certitude is sovereign because I have the leisure to observe the photograph with intensity; but also, however long I

from the eye's viewpoint, "the essence of the image is to be altogether outside, without intimacy, and yet more inaccessible and mysterious than the thought of the innermost being; without signification, yet summoning up the depth of any possible meaning; unrevealed yet manifest,

106/

extend this observation, it teaches me nothing. It is precisely in this *arrest* of interpretation that the Photograph's certainty resides: I exhaust myself realizing that *this-hasbeen*; for anyone who holds a photograph in his hand, here is a fundamental belief, an "ur-doxa" nothing can undo, unless you prove to me that this image *is not* a photograph. But also, unfortunately, it is in proportion to its certainty that I can say nothing about this photograph.

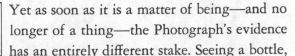

an iris stalk, a chicken, a palace photographed involves only reality. But a body, a face, and what is more, frequently, the body and face of a beloved person? Since Photography (this is its *noeme*) *authenticates* the existence of a certain being, I want to discover that being in the photograph completely, *i.e.*, in its essence, "as into itself . . ." beyond simple resemblance, whether legal or hereditary. Here the Photograph's platitude becomes more painful, for it can correspond to my fond desire only by something inexpressible: evident (this is the law of the Photograph) yet improbable (I cannot prove it). This something is what I call the *air* (the expression, the look).

The *air* of a face is unanalyzable (once I can decompose, I prove or I reject, in short I doubt, I deviate from the Photograph, which is by nature totally evidence: evi-

"No impulse of power"

R. Avedon: A. Philip Randolph (The Family). 1976

dence is what does not want to be decomposed). The air is not a schematic, intellectual datum, the way a silhouette is. Nor is the air a simple analogy-however extendedas is "likeness." No, the air is that exorbitant thing which induces from body to soul-animula, little individual soul, good in one person, bad in another. Hence I was leafing through the photographs of my mother according to an initiatic path which led me to that cry, the end of all language: "There she is!": first of all a few unworthy pictures which gave me only her crudest identity, her legal status; then certain more numerous photographs in which I could read her "individual expression" (analogous photographs, "likenesses"); finally the Winter Garden Photograph, in which I do much more than recognize her (clumsy word): in which I discover her: a sudden awakening, outside of "likeness," a satori in which words fail, the rare, perhaps unique evidence of the "So, yes, so much and no more."

The air (I use this word, lacking anything better, for the expression of truth) is a kind of intractable supplement of identity, what is given as an act of grace, stripped of any "importance": the air expresses the subject, insofar as that subject assigns itself no importance. In this veracious photograph, the being I love, whom I have loved, is not separated from itself: at last it coincides. And, mysteriously, this coincidence is a kind of metamorphosis. All the photographs of my mother which I was looking through were a little like so many masks; at the last, suddenly the mask vanished: there remained a soul, ageless but not timeless, since this air was the person I used to see, consubstantial with her face, each day of her long life.

Perhaps the air is ultimately something moral, mysteriously contributing to the face the reflection of a life value? Avedon has photographed the leader of the American Labor Party, Philip Randolph (who has just died, as I write these lines); in the photograph, I read an air of goodness (no impulse of power: that is certain). Thus the air is the luminous shadow which accompanies the body; and if the photograph fails to show this air, then the body moves without a shadow, and once this shadow is severed, as in the myth of the Woman without a Shadow, there remains no more than a sterile body. It is by this tenuous umbilical cord that the photographer gives life; if he cannot, either by lack of talent or bad luck, supply the transparent soul its bright shadow, the subject dies forever. I have been photographed a thousand times; but if these thousand photographs have each "missed" my air (and perhaps, after all, I have none?), my effigy will perpetuate (for the limited time the paper lasts) my identity, not my value. Applied to someone we love, this risk is lacerating: I can be frustrated for life of the "true image." Since neither Nadar nor Avedon has photographed my mother, the survival of this image has depended on the luck of a picture made by a provincial photographer who, an indifferent mediator, himself long since dead, did not know that what he was making permanent was the truth-the truth for me

Trying to make myself write some sort of com-46 mentary on the latest "emergency" reportage, I tear up my notes as soon as I write them.

What-nothing to say about death, suicide, wounds, accidents? No, nothing to say about these photographs in which I see surgeons' gowns, bodies lying on the ground, broken glass, etc. Oh, if there were only a look, a subject's look, if only someone in the photographs were looking at me! For the Photograph has this power-which it is increasingly losing, the frontal pose being most often considered archaic nowadays-of looking me straight in the eye (here, moreover, is another difference: in film, no one ever looks at me: it is forbidden-by the Fiction).

The photographic look has something paradoxical about it which is sometimes to be met with in life: the other day, in a café, a young boy came in alone, glanced around the room, and occasionally his eyes rested on me; I then had the certainty that he was looking at me without however being sure that he was seeing me: an inconceivable distortion: how can we look without seeing? One might say that the Photograph separates attention from perception, and yields up only the former, even if it is impossible without the latter; this is that aberrant thing, noesis without noeme, an action of thought without thought, an aim without a target. And yet it is this scandalous movement which produces the rarest quality of an air. That is the paradox: how can one have an intelligent

/ 1 1 1

"How can one have an intelligent air without thinking of anything intelligent? . . ."

A. Kertész: Piet Mondrian in His Studio. Paris, 1926

air without thinking about anything intelligent, just by looking into this piece of black plastic? It is because the look, eliding the vision, seems held back by something interior. That lower-class boy who holds a newborn puppy against his cheek (Kertész, 1928), looks into the lens with his sad, jealous, fearful eyes: what pitiable, lacerating pensiveness! In fact, he is looking at nothing; he *retains* within himself his love and his fear: that is the Look.

Now the Look, if it insists (all the more, if it lasts, if it traverses, with the photograph, Time)—the Look is always potentially crazy: it is at once the effect of truth and the effect of madness. In 1881, inspired by a splendid scientific spirit and investigating the physiognomy of the sick, Galton and Mohamed published certain plates of faces . . . It was concluded, of course, that no disease could be read in them. But since all these patients still look at me, nearly a hundred years later, I have the converse notion: that whoever looks you straight in the eye is mad.

Such would be the Photograph's "fate": by leading me to believe (it is true, one time out of how many?) that I have found what Calvino calls "the true total photograph," it accomplishes the unheard-of identification of reality ("*that-bas-been*") with truth ("there-she-is!"); it becomes at once evidential and exclamative; it bears the effigy to that crazy point where affect (love, compassion, grief, enthusiasm, desire) is a guarantee of Being. It then approaches, to all intents, madness; it joins what Kristeva calls "*la vérité folle*."

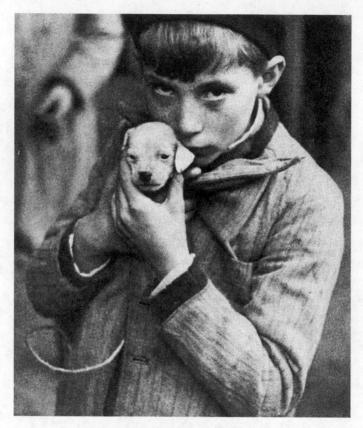

"He is looking at nothing; he retains within himself his love and his fear: that is the Look . . ."

A. Kertész: The Puppy. Paris, 1928

47

The *noeme* of Photography is simple, banal; no depth: "that has been." I know our critics: What! a whole book (even a short one) to

discover something I know at first glance? Yes, but such evidence can be a sibling of madness. The Photograph is an extended, loaded evidence-as if it caricatured not the figure of what it represents (quite the converse) but its very existence. The image, says phenomenology, is an object-as-nothing. Now, in the Photograph, what I posit is not only the absence of the object; it is also, by one and the same movement, on equal terms, the fact that this object has indeed existed and that it has been there where I see it. Here is where the madness is, for until this day no representation could assure me of the past of a thing except by intermediaries; but with the Photograph, my certainty is immediate: no one in the world can undeceive me. The Photograph then becomes a bizarre medium, a new form of hallucination: false on the level of perception, true on the level of time: a temporal hallucination, so to speak, a modest, shared hallucination (on the one hand "it is not there," on the other "but it has indeed been"): a mad image, chafed by reality.

I am trying to render the special quality of this hallucination, and I find this: the same evening of a day I had again been looking at photographs of my mother, I went to see Fellini's *Casanova* with some friends; I was sad, the

/115

film exasperated me; but when Casanova began dancing with the young automaton, my eyes were touched with a kind of painful and delicious intensity, as if I were suddenly experiencing the effects of a strange drug; each detail, which I was seeing so exactly, savoring it, so to speak, down to its last evidence, overwhelmed me: the figure's slenderness, its tenuity-as if there were only a trifling body under the flattened gown; the frayed gloves of white floss silk; the faint (though touching) absurdity of ostrich feathers in the hair, that painted yet individual, innocent face: something desperately inert and yet available, offered, affectionate, according to an angelic impulse of "good will" . . . At which moment I could not help thinking about Photography: for I could say all this about the photographs which touched me (out of which I had methodically constituted Photography itself).

I then realized that there was a sort of link (or knot) between Photography, madness, and something whose name I did not know. I began by calling it: the pangs of love. Was I not, in fact, in love with the Fellini automaton? Is one not in love with certain photographs? (Looking at some photographs of the Proustian world, I fall in love with Julia Bartet, with the Duc de Guiche ...) Yet it was not quite that. It was a broader current than a lover's sentiment. In the love stirred by Photography (by certain photographs), another music is heard, its name oddly old-fashioned: Pity. I collected in a last thought the images which had "pricked" me (since this is the action of the *punctum*), like that of the black woman with the gold necklace and the strapped pumps. In each of them, inescapably, I passed beyond the unreality of the thing represented, I entered crazily into the spectacle, into the image, taking into my arms what is dead, what is going to die, as Nietzsche did when, as Podach tells us, on January 3, 1889, he threw himself in tears on the neck of a beaten horse: gone mad for Pity's sake.

Society is concerned to tame the Photograph, to temper the madness which keeps threatening to explode in the face of whoever looks at it. To do this, it possesses two means.

The first consists of making Photography into an art, for no art is mad. Whence the photographer's insistence on his rivalry with the artist, on subjecting himself to the rhetoric of painting and its sublimated mode of exhibition. Photography can in fact be an art: when there is no longer any madness in it, when its noeme is forgotten and when consequently its essence no longer acts on me: do you suppose that looking at Commander Puyo's strollers I am disturbed and exclaim "That-has-been!"? The cinema participates in this domestication of Photography-at least the fictional cinema, precisely the one said to be the seventh art; a film can be mad by artifice, can present the cultural signs of madness, it is never mad by nature (by iconic status); it is always the very opposite of an hallucination; it is simply an illusion; its vision is oneiric, not ecmnesic.

1117

The other means of taming the Photograph is to generalize, to gregarize, banalize it until it is no longer confronted by any image in relation to which it can mark itself, assert its special character, its scandal, its madness. This is what is happening in our society, where the Photograph crushes all other images by its tyranny: no more prints, no more figurative painting, unless henceforth by fascinated (and fascinating) submission to the photographic model. Looking around at the customers in a café, someone remarked to me (rightly): "Look how gloomy they are! nowadays the images are livelier than the people." One of the marks of our world is perhaps this reversal: we live according to a generalized image-repertoire. Consider the United States, where everything is transformed into images: only images exist and are produced and are consumed. An extreme example: go into a New York porn shop; here you will not find vice, but only its tableaux vivants (from which Mapplethorpe has so lucidly derived certain of his photographs); it is as if the anonymous individual (never an actor) who gets himself tied up and beaten conceives of his pleasure only if this pleasure joins the stereotyped (worn-out) image of the sado-masochist: pleasure passes through the image: here is the great mutation. Such a reversal necessarily raises the ethical question: not that the image is immoral, irreligious, or diabolic (as some have declared it, upon the advent of the Photograph), but because, when generalized, it completely de-realizes the human world of conflicts and desires, under cover of illustrating it. What characterizes the so-called advanced societies is that they

118/

today consume images and no longer, like those of the past, beliefs; they are therefore more liberal, less fanatical, but also more "false" (less "authentic")—something we translate, in ordinary consciousness, by the avowal of an impression of nauseated boredom, as if the universalized image were producing a world that is without difference (indifferent), from which can rise, here and there, only the cry of anarchisms, marginalisms, and individualisms: let us abolish the images, let us save immediate Desire (desire without mediation).

Mad or tame? Photography can be one or the other: tame if its realism remains relative, tempered by aesthetic or empirical habits (to leaf through a magazine at the hairdresser's, the dentist's); mad if this realism is absolute and, so to speak, original, obliging the loving and terrified consciousness to return to the very letter of Time: a strictly revulsive movement which reverses the course of the thing, and which I shall call, in conclusion, the photographic ecstasy.

Such are the two ways of the Photograph. The choice is mine: to subject its spectacle to the civilized code of perfect illusions, or to confront in it the wakening of intractable reality.